HOARDS FROM WILTSHIRE

Richard Henry

AMBERLEY

First published 2021

Amberley Publishing
The Hill, Stroud
Gloucestershire, GL5 4EP

www.amberley-books.com

Copyright © Richard Henry, 2021

The right of Richard Henry to be identified as the
Author of this work has been asserted in accordance
with the Copyrights, Designs and Patents Act 1988.

ISBN 978 1 3981 0074 9 (print)
ISBN 978 1 3981 0075 6 (ebook)

British Library Cataloguing in Publication Data.
A catalogue record for this book is available from
the British Library.

Typeset in 10pt on 13pt Celeste.
Origination by Amberley Publishing.
Printed in the UK.

Acknowledgements

The manuscript for *Hoards from Wiltshire* was submitted in October 2019 and was originally due to be published in June 2020. Twelve months on, Covid-19 has had an impact and understandably led to delays in the publication of this book. I would like to thank all of the staff at Amberley who have worked on the publication, in particular Connor Stait.

This book is the culmination of a range of research projects that were mostly undertaken while I was the Finds Liaison Officer (FLO) for Wiltshire. It could not have been written without the input of every finder, FLO, assistant and volunteer who has worked on finds from Wiltshire; in particular, my former volunteers at Salisbury Museum. I must also thank every specialist who has provided comments on records, assisted with fieldwork and provided support or training. Particular thanks must go to Michael Grant, Ruth Pelling, David Roberts and Pete Marshall for their work on the Pewsey vessel hoard.

The majority of the datasets and the supporting images in this book have come from the Portable Antiquities Scheme database (PAS), which is an excellent resource. It would not be the success it has been without the dedication of everyone who works for the PAS. Thanks to Roger Bland, Dot Boughton, Historic England, the PASt Landscapes project, the Salisbury Museum, Swindon Museum and Art Gallery, Wessex Archaeology, Wiltshire Council Archaeology Service and the Wiltshire Museum for their permission to use images and figures within the book. The illustrations have been produced by Nick Griffiths or Claire Goodey, or were originally published in the *London Illustrated News*. Every attempt has been made to seek permission for copyright material used in this book. CC BY-SA supporting images were obtained from the Portable Antiquities Scheme database from the British Museum, the Birmingham Museums Trust, Derby Museums Trust, Dorset County Council, Leicestershire County Council, and Somerset County Council. However, if we have inadvertently used copyright material without

permission or acknowledgement we apologise will make the necessary correction at the first opportunity.

Thank you to Roger Bland, Sam Moorhead, David Roberts, Derek Pitman, Jörn Schuster, Naomi Payne, Rebecca Drummond, Henrietta and particularly Dot Boughton for the thought-provoking discussions that added to this book. Thank you to Naomi Payne, Sophia Sample, Rebecca Drummond and Alice Roberts-Pratt for their assistance with proofreading and commenting on the draft versions of the text. Thank you to those who have assisted in providing material relating to the research, including Megan Berrisford at Salisbury Museum, Lorraine Mepham at Wessex Archaeology, Lisa Brown at Wiltshire Museum and Thomas Sunley at the Wiltshire Archaeology Service.

Finally, thank you to Cath and my parents Alison and Chris. This book is dedicated to them.

What is a Hoard?

Usually when we think of a hoard, we think of treasure; hoards of gold objects such as the Staffordshire hoard, or thousands of coins found in a vessel like the South Leicestershire Roman coin hoard. Yet, such finds form only a small fraction of those that have been discovered. Additionally, what is regarded as treasure is affected by our preconceived ideas; often those archaeological discoveries that may initially seem mundane in contrast to spectacular discoveries, are some of the most significant, providing us with an insight into the past.

In the broadest sense, hoarding is the deposition of a group of artefacts or coins, typically buried in the earth. However, they do not necessarily need to have been deliberately placed. For example, the loss of a group of coins within a purse can be a hoard. Furthermore, although hoards are usually buried in the earth, this is not always the case. In 2017, 913 gold sovereigns and half sovereigns dating between 1847 and 1915 were discovered in a piano while it was being returned after it had been donated to the Community College in Bishops Castle, Shropshire.

There can also be a difference between what is designated a hoard and what would legally be defined as Treasure. The Treasure Act (1997) defines potential Treasure as: two or more coins made of at least 10 per cent precious metal over 300 years old which are 'of the same find'; ten or more base metal coins over 300 years old which are 'of the same find'; any artefact of at least 10 per cent precious metal over 300 years old; any prehistoric object which contains any percentage of precious metal; or, any find which would have been previously defined as Treasure Trove.

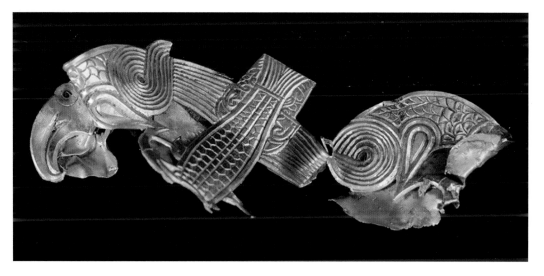

A gold zoomorphic mount from the Staffordshire hoard. (British Museum)

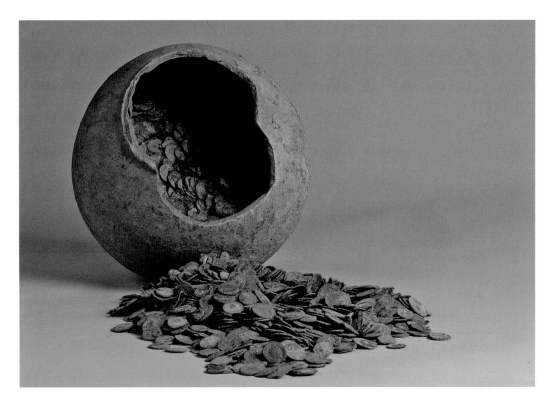

The South Leicestershire Roman coin hoard. (British Museum)

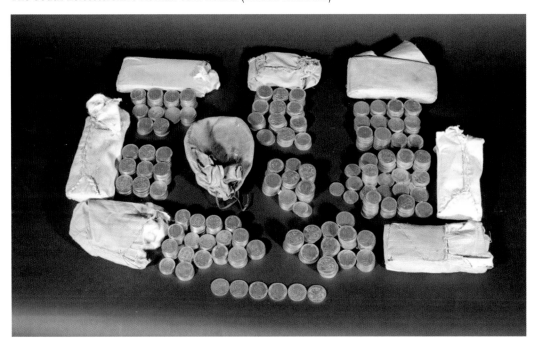

The Piano hoard of gold sovereigns and half sovereigns. (Birmingham Museums Trust)

A later amendment from 2003 also defined any two or more metallic prehistoric objects 'of the same' find as Treasure.

In England, Northern Ireland and Wales, the Treasure Act replaced the Treasure Trove common law. However, in Scotland, Treasure Trove continues, based on the Scots common law *bona vacantia* (ownerless goods).

There were limitations with Treasure Trove. For a hoard to qualify as Treasure Trove, it had to be shown to have been buried with the intention of recovery. The Treasure Act also has limitations, a hoard which is less than 300 years old, or one that is comprised of any base metal from the Roman to modern periods are not legally classed as Treasure. Examples of this are the Roman hoards from Pewsey and Kingston Deverill – as they are copper-alloy vessels rather than precious metal, they are not considered Treasure.

The Treasure Act and the process involved when a discovery is classed as Treasure is complex. Items that fall under the Treasure Act or Treasure Trove are initially offered to the local museum. If they express an interest, they must reward the finder and the landowner with its market value. This is based on the expected auction hammer price, rather than what the value may be in a private sale.

Why Were Hoards Deposited?

The reasons for the deposition of hoards can vary significantly depending of the type of artefact(s) and the period the hoard dates from. For example, the deposition of coin hoards is often categorised by archaeologists as accidental losses, abandoned hoards or hoards deposited at a time of external threat. Other categories can include preventing others from gaining valuable raw materials or ritual deposition. The hoard of over 875,000 iron nails buried in a pit when the

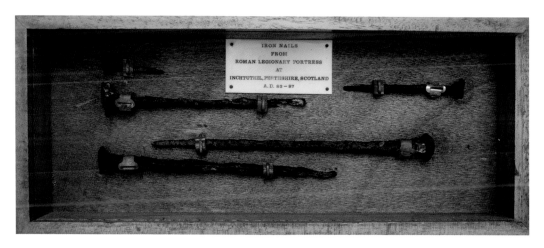

Roman nails from the legionary fort at Inchtuthil, Scotland. (Richard Henry)

Romans abandoned the legionary fort at Inchtuthil in Scotland is probably the most famous example of preventing access to valuable raw materials. Inchtuthil is also a good example of challenging our perceptions of a hoard. When hoards are announced in the press, the focus of the story is usually if the find is gold or silver, or the potential monetary value of 'treasure'. The nails at Inchtuthil weighed over ten tons. Such was the value of the resource of good quality wrought iron to the tribes in Scotland, the nails were elaborately concealed in a pit and the legionary fort was burnt to the ground. In this context, the iron was far more valuable than any precious metal.

When considering ritual deposits, the evidence varies depending on the period. In the Bronze Age and Early Iron Age there is a correlation between hoards and river valleys, in particular near the source of rivers. In the 1970s, while dredging a river near Melksham a hoard of Early Iron Age objects was discovered. Dating from 800–600 BC, it consisted of three copper-alloy spearheads, two iron spearheads, a fragment of a copper-alloy rapier and three horse harness decorations. Two of the copper-alloy horse harness decorations were ritually killed prior to deposition;

The Iron Age
hoard from
Melksham.
(Dot Boughton)

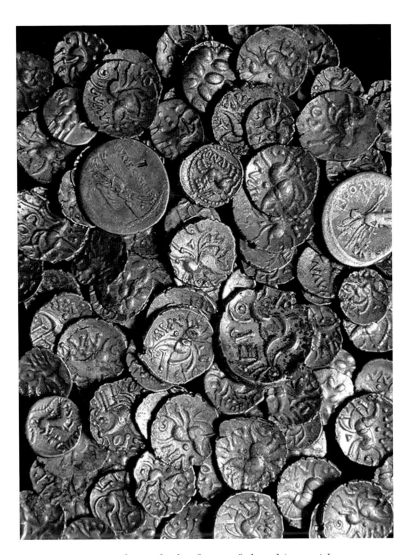

Iron Age coins from the Hallaton hoard. (Leicestershire County Council)

one by being stabbed eleven times through the front of the object with a spear, a second was stabbed four times.

Ritual deposits have also been observed in Iron Age hoards. Those from Hallaton in Leicestershire and Chiseldon in Wiltshire are both linked to feasting. However, hoards from the Roman period are rarely interpreted as votive deposits. This is partly because the character of votive deposits changed during the Roman period, with donatives offered at temples becoming more prevalent. Nevertheless, there still remained a connection with water, including sacred springs such as Bath in Somerset and Springhead in Kent. The limited number of hoards being described as votive deposits may also be due in part to the wording of the former Treasure Trove common law. For an item to be defined as Treasure Trove, the hoard needed to be viewed as deposited with the intention of recovery. Therefore, any argument which went against this, such as a votive deposition, would be detrimental to a

museum's ability to acquire the hoard. Such factors should be considered when we ascribe modern interpretations for deposition.

Particular types of material have been interpreted as ritualised, including pewter and iron hoards. Many of these were deposited within deep pits or wells. Examples of Late Roman iron hoards include those from: Jordan Hill, Dorset, which was deposited in a votive shaft; Silchester, Hampshire, found in a well in 1900; and the pewter hoard from Appleford, Berkshire, which was probably deposited in a timber-lined well.

Often hoards are categorised as being concealed at times of threat with the intention of recovery. This is particularly the case with coin hoards. However, there are exceptions. The hoard from Frome, Somerset, consisted of 52,503 coins. This made it the second largest coin hoard ever recovered from Britain, after the Cunetio hoard from Mildenhall near Marlborough, Wiltshire. As in total the coins weigh over 160 kg, the vessel could never carry the weight. It therefore must have been deposited within the ground prior to being filled. The coins appear to have been added during a single occasion, as the latest coins (of the Roman Emperor Carausius AD 286–93) were found in the lower layers of the vessel. A coin hoard of late Roman silver *siliquae* that had been deposited about 100 years later was also found in the same field. These patterns of potential ritual deposits and multiple hoards discovered in close proximity will be further explored in this book.

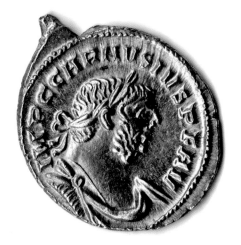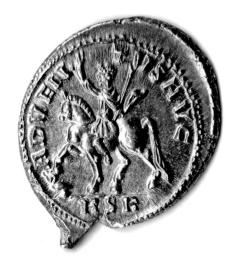

A Roman silver *denarius* of Carausius from the Frome hoard. (Portable Antiquities Scheme)

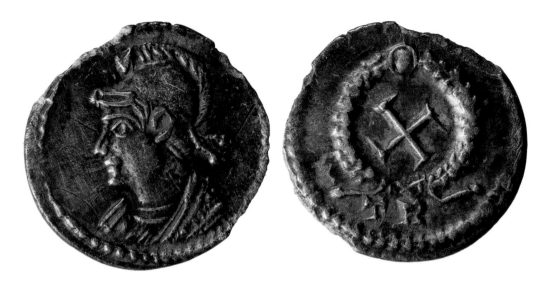

A Roman silver *half-siliquae* from the Frome *siliquae* hoard. (Somerset County Council)

The Landscape

When considering why a hoard was deposited in a certain place at a certain time, it is important to not only consider the elements of the hoard itself, but also the context of the wider landscape. The location and method of deposition are often considered when discussing prehistoric hoards, but with those from later periods. In particular this is the case with coin hoards – the focus is usually on the content not the context of the deposit. The landscape factors to be considered depend on the period in which the hoard was deposited, but can include elements such as roads, rivers, or settlements. Finally, the proximity to other features including barrows and temples as well as elements which are harder to define such as boundaries can be important. The date of the hoard also affects which landscape elements are considered to be key. When evaluating hoards in the Roman period, Roman roads are often the main focus. However, although land routes improved in this period, the river network remained significant and their importance should not be overlooked.

The landscape of Wiltshire has been described as Chalk and Cheese because of the southern chalk and rich pasture to the north. Two ways of exploiting the landscape have dominated for millennia: arable land and pasture. The chalk downland is dry and crossed by steep-sided valleys, known as combes. The grassland of the chalk has been extensively cultivated and managed. An advantage of the chalk downland in contrast to the clay pasture is that archaeological remains are often well preserved. They are clearly visible on aerial photographs, leading to a bias in the archaeological record towards the chalk. One of the most visible forms of archaeological remains in the county are the expansive 'Celtic' field systems.

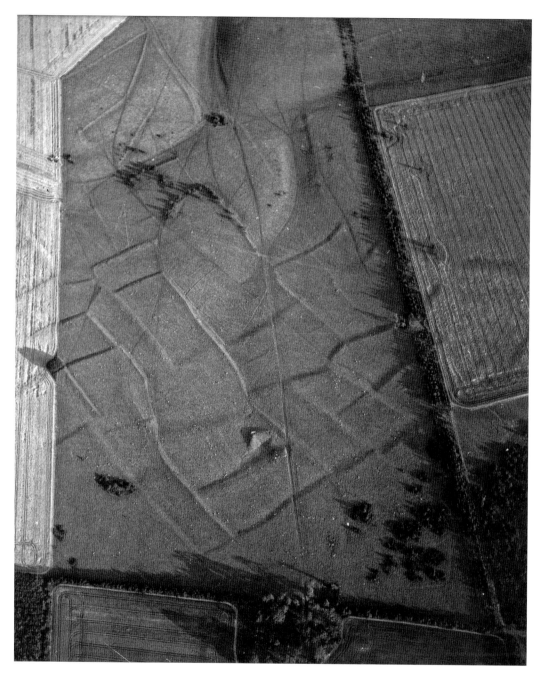

'Celtic' field systems at Pertwood down. (Wiltshire Council Archaeology Service – AER 1501 Oblique 27/07/81)

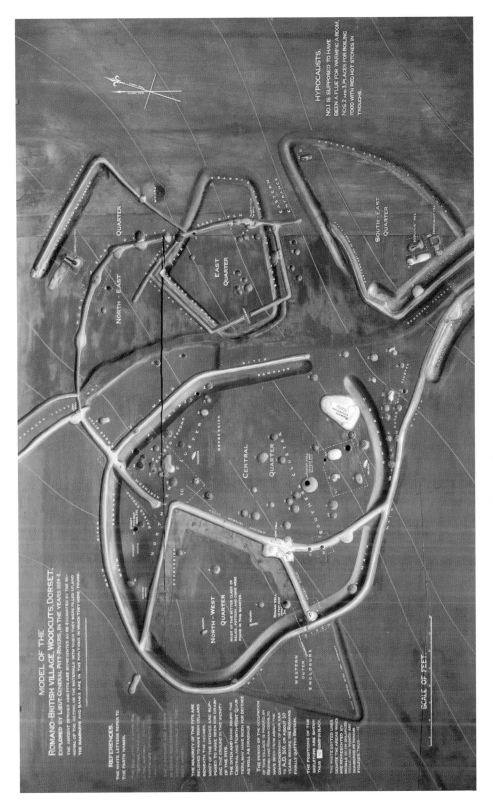

The Pitt-Rivers model of his excavation at Woodcutts. (Richard Henry)

The name of these field systems implies an Iron Age date, but they can, however, date from the Bronze Age (Rackham 1986). Research in the area shows that there was a resurgence of activity in the Late Iron Age that intensified in the Roman period when these field systems were expanded (Fowler 2000).

During the first millennium BC, the majority of settlements on the chalk downland were single farmsteads and small communities. The excavations at Tollard Royal provide a representative example of a small 'farmstead' type settlement in the region, with evidence for a mixed farming economy, most likely worked by a single family (Wainwright 1968). Sites such as Rotherley and Woodcutts, which were both excavated by General Augustus Pitt-Rivers, appear to represent a larger establishment with extended families (Cunliffe 1991).

Cunliffe (2000, 43) identified three broad resource zones as part of the Danebury Environs Project: open downland, woodland and the river valley flood plain. These are useful elements to consider when thinking about the wider landscape of Wiltshire. Each resource zone, as defined by Cunliffe, would have had different benefits and influenced the location of settlements in specific areas. River valleys were well watered and in protected positions, making them particularly fertile and well suited for cattle rearing.

Cunliffe (2000) made a distinction between watered downland and dry land. Dry land is defined as being over 1 km from the nearest water supply. Sites located on the Great Ridge in Wiltshire, including Stockton Earthworks and Hamshill Ditches, did not have easy access to water supplies. Instead water could have been accessed from springs, dew ponds, or substantial wells such as those from Woodcutts which were over 57 m deep. These examples highlight the challenges we face when setting such distinctions such as dry land to evaluate the resources available within the wider landscape in the past.

Wood pasture and managed woodland are both historically documented over the last 1,200 years and are likely to have been in use from the Neolithic onwards (Rackham 1986). Managed woodland increases the output of useful materials and is a renewable resource that would have been vital in areas where large quantities of fuel were required, particularly for industrial sites (Dark and Dark 1997). These resources would have also been essential for building materials and agricultural works such as fences.

Attempting to map areas of the landscape which may have been managed woodland in the past can be challenging. It has been argued that hills capped with clay-with-flints geological deposits retained a forest cover which was managed (Hostetter and Noble Howe 1997; Cunliffe 2000). This map shows potential resource zones as defined by Cunliffe (2000) in the environs of the Kingston Deverill patera hoard in south west Wiltshire. By highlighting the river valleys,

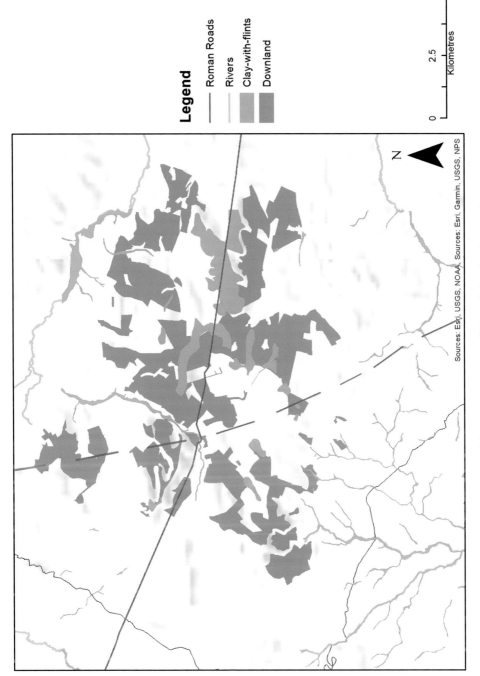

0 2.5 5

Kilometres

N

Sources: Esri, USGS, NOAA. Sources: Esri, Garmin, USGS, NPS

Potential resource zones in the environs of the Kingston Deverill hoard. (Richard Henry)

downland and areas of clay-with-flints it provides a potential insight to how the landscape may have been managed and what resourced could have been utilised in the past.

The transition from the Iron Age to the Roman period, after the Roman Conquest in AD 43, provides a useful case study when considering the wider landscape context of hoards. Although there was significant change, there was also continuity. Traditional models of Late Iron Age society in Britain are based on the social entities of tribes. The names of these tribes are based on the Roman *civitas* groups defined in Ptolemy's *Geographia* which was completed in the second century. Wiltshire falls within three *civitates*; the Durotriges to the south, the Dobunni to the north and the Atrebates to the east. The numismatic evidence suggests there may also have been an east Wiltshire tribe or sub-tribe, which struck distinctive gold and silver issues *c.* 50–35 BC before being absorbed by the Dobunni (Robinson 1977). Previous studies have suggested that to the south of the river Wylye is the Durotrigan *civitas,* while north Wiltshire, extending as far south as Cold Kitchen Hill, is part of the Dobunnic *civitas.*

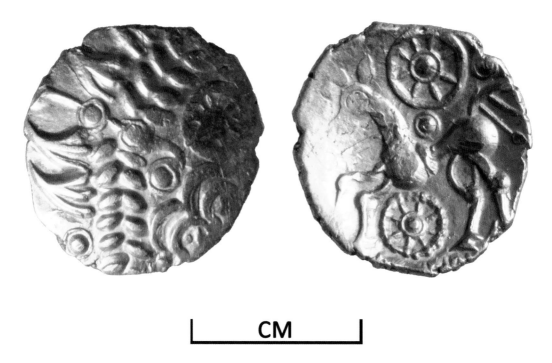

An Iron Age gold quarter stater of the East Wiltshire tribe. (Salisbury Museum)

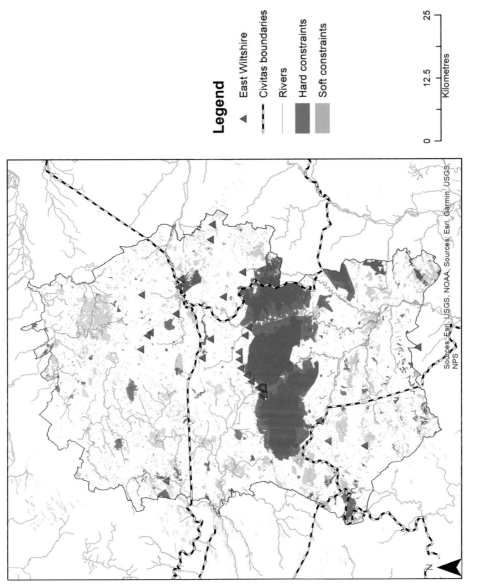

Legend

▲ East Wiltshire

▬▬ Civitas boundaries

—— Rivers

▮ Hard constraints

▮ Soft constraints

0 12.5 25
Kilometres

Sources: Esri, USGS, NOAA. Sources: Esri, Garmin, USGS, NPS

N

Distribution of coinage of the East Wiltshire tribe. (Richard Henry)

The Late Iron Age was a dynamic period with a large population increase, evidence of coin-using groups and long-distance trade. The economy was primarily agricultural, and the typical rural settlement was a farmstead. These farmsteads were densely distributed with associated field systems. The Late Iron Age also saw a change from a mixture of crops being farmed, to a single crop. Changes in species used also allowed for variation in the period the crop was sown, enabling harvesting and ploughing to be spread over the year (Cunliffe 2000).

Hillforts dominate the public's perception of the Iron Age and it has been argued that they fulfilled central place functions (Cunliffe 1991). By the Late Iron Age, we see large nucleated settlements (oppida) develop, often located at major route crossings (Cunliffe 1991; Dark and Dark 1997). Cunliffe (1991) argues that the apparent transition from developed hillforts to enclosed oppida, represents the change from a 'pre-urban to fully urban system'. In the Late Iron Age, there was a move away from hillforts, which left many sites unoccupied. However, Maiden Castle and Hod Hill remained important local centres with evidence of urbanisation (Cunliffe 1991; Dark and Dark 1997). The development of this pattern of oppida and farmsteads was only one aspect of a much more complex set of social and economic relationships. There were also specialist production sites and a series of coastal trading sites such as Hengistbury Head in Dorset, which are evidence for long distance trade (Sherratt 1996; Dark and Dark 1997).

Although the first 100 years following the Roman Conquest in AD 43 saw major changes to urban centres, in many rural settlements traditional lifestyles continued as before. The Conquest led to access to new markets which allowed for increased imports. There is evidence of major dislocation on the higher parts of Salisbury Plain. With the exception of Coombe Down, Iron Age enclosures were abandoned in favour of nucleated settlements and new establishments in the valleys (Lawson 2007).

The Romans also encouraged the development of market exchange and the use of coinage. There is significant evidence to suggest that many Wessex downland settlements of the Late Roman period enjoyed a high standard of living and had access to high quality materials and the coin using economy (Moorhead 2001; Roberts 2014). The maximum exploitation of the agrarian potential for the area as a whole appears to be realised only in the Late Roman period. The fourth century witnessed a dramatic intensification of agricultural and settlement activity on much of the chalk land (Fowler 2000). This is due to a number of factors including extensive manuring and advances in plough technology, such as iron ploughshares and a mouldboard which cut neat and straight furrows in the soil and turning the soil to bring nutrients to the surface. These developments led to the further exploitation of heavier soils and changed agricultural techniques allowing the cultivation of any soil.

How and When Have Hoards Been Discovered?

The most detailed records we have available for when and how hoards have been discovered are for coin hoards. These have been extensively catalogued and researched for decades. The most recent example is the Iron Age and Roman coin hoard project (see Bland 2018). Whereas for hoards of artefacts, it can be difficult to date them without further archaeological evidence; coin hoards can often be very closely dated as the last coin will provide a *terminus post quem* which is the earliest possible date of the deposit. They are also the most prolific type of hoard found in the country, with over 5,400 individual hoards recorded, of which over 3,000 are Roman. For these reasons, coin hoards are able to provide a useful insight into understanding the change in the number of recorded discoveries, as well as the change in the rate of deposition over the last 2,200 years.

The earliest recorded discoveries of Roman coin hoards in Britain are from the fourteenth century. The following centuries saw these discoveries steadily increase. From the 1970s onwards, particularly with the advent of metal detecting, the rate has been growing. Indeed, the greatest rise has been since the 1990s following the introduction of the Treasure Act. Coin hoards can therefore offer us an insight into how the discovery of hoards has changed over time.

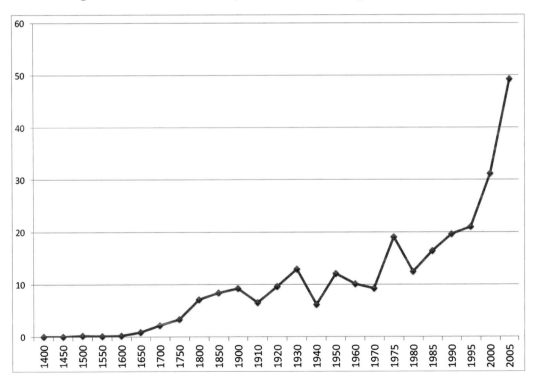

The increase in the number of hoards reported per annum. (Roger Bland)

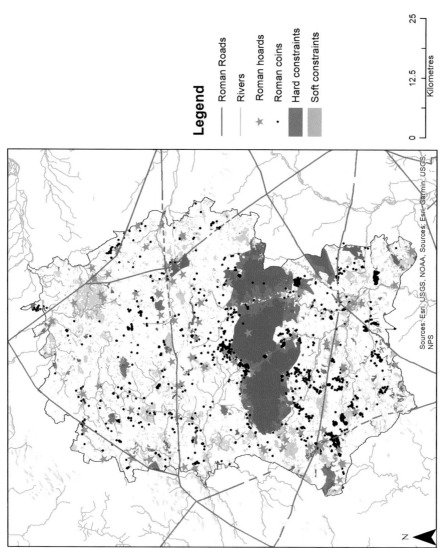

The distribution of the Roman coin hoards mapped against Roman coins recorded with the PAS and areas where metal detecting is banned (hard constraints) or unlikely (soft constraints) in Wiltshire. (Richard Henry)

For Wiltshire, we know of over 140 Roman coin hoards that have been recovered from the county. There are records of hoards being found from the 1650s onwards. Over the following two centuries, one or two hoards were recorded per decade in Wiltshire. The number then began to increase from the 1850s. Corresponding with the general trend, the introduction of metal detecting has seen the number of hoards discovered in Wiltshire, increasing significantly during the last fifty years with over fifty reported. Prior to this development in technology, the majority of the discoveries were made during agricultural activity, large scale construction projects or building works.

The earliest recorded discovery of a coin hoard from Wiltshire was made in Sandy Lane in March 1653:

> In Weeke field, by Sandy Lane in the parish of Hedington, digging the earth, in March 1653, deeper than the plough had gone, to sowe carrots, they found foundations of howses, and coales, for at least a quarter of a mile long, and a great quantity of Roman money, silver and copper, of the Emperors. Among the rest was an earthen pott of the colour of a crucible, and of the shape of a Prentice's Christmas Box, with a slit in it, containing about a quart, which was near full of money. I gott the pott, and about a quarter of a pint of the money, most of it in copper, which was stolen by a servant from me. [...] Among the coin there was a good deal of small copper pieces no bigger than a silver single penny [...].

There are, however, some more unusual examples of hoard discovery. In 1871, a hoard from East Harnham was discovered by a cow in a meadow. The hoard is now at Salisbury Museum and its discovery was recorded by William Blackmore, the founder of the Blackmore Museum wrote in his notebook:

> On April 8th, 1871 a labouring man brought me a number of coins in a bag, which he had found the previous day in a meadow at Harnham: from his account, an old cow had most fortunately trodden upon the spot where the coins had been deposited by the original owner. This unusual weight broke the urn in which the coins were placed and exposed the long hidden treasure to view. The urn was about the size of an ordinary pitcher, of the rough unglazed ware in common use by the Romans and Romanised Britons at the end of the third century and from the fragments of pottery brought me with the coins had evidently been covered by a second smaller vessel of the same kind of ware.

The quality of the information recorded about each discovery varies significantly. It is largely dependent on if the coins survive, usually within a museum collection, which allows for further assessment. If the discovery has been dispersed (for example the coins have been sold off in groups over the years), the surviving record has generally improved over time as structures have been put in place setting out

what information should be recorded. Since the introduction of the Treasure Act and new analytical techniques, the information we have available for research allows us to interrogate the evidence in a greater detail, offering us new insights.

What Can Hoards Tell Us?

This book will focus on ten hoards grouped into three of the themes of hoarding discussed above: potential ritual deposits, multiple hoards deposited in the same location, and hoards potentially deposited at times of threat. The examples have been chosen because although they could initially be interpreted in a specific, simplistic way, when we look deeper, they become more complex and make us

William Blackmore, founder of the Blackmore Museum in Salisbury. (Salisbury Museum)

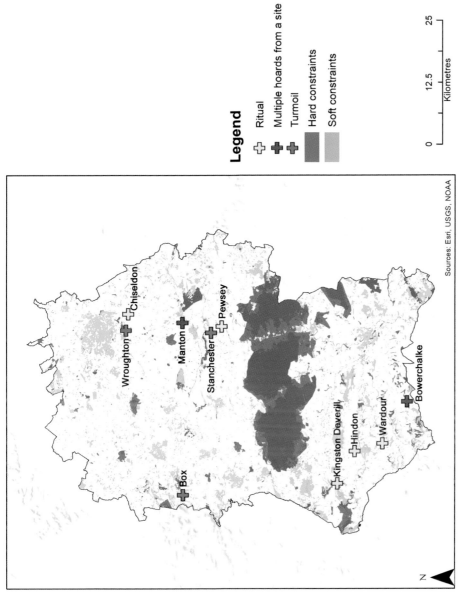

The hoards discussed within this book mapped against areas where metal detecting is banned (hard constraints) or unlikely (soft constraints) in Wiltshire. (Richard Henry)

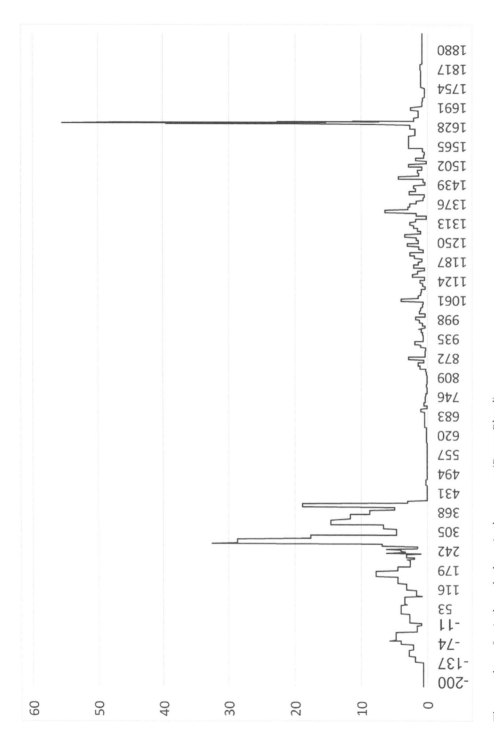

The number of coin hoards deposited per year. (Roger Bland)

consider them holistically. Such re-evaluated interpretations are based on the evidence presented within the hoard in conjunction with our knowledge of the past. The reason for deposition can be multi-faceted and intertwined. When considering hoarding as a whole, we can trace developments over time. Undertaking scientific analysis further enables us to understand particular hoards and periods of our history in greater detail.

It is not just what is in a hoard that tells us about the past. The change in the quantity of hoards deposited changes over time. The next image shows the number of discovered coin hoards deposited per year from 200 BC to the 1930s in Britain. There is clearly a significant variation in the number of coin hoards deposited per year, with the largest peak occurring during the English Civil War (AD 1642–51). Often the greater the number of coins in circulation, the greater the quantity of hoards as more coins are available. Comparing the number of hoards from the Anarchy of AD 1135–53 against recorded coin loss and the Civil War highlights this disparity. Coin hoards from the Anarchy were deposited at a higher rate than the preceding and succeeding years. Yet when compared with the peaks in the Roman period and the Civil War, as only four hoards are recorded from the county they could be seen as inconsequential. For this reason, when evaluating coin hoards, the wider distribution of single coins recorded with the Portable Antiquities Scheme (PAS) which circulated when the hoard was deposited will also be considered.

When evaluating finds recorded with the PAS and mapping them against hoards, the bias in the PAS dataset needs to be considered (see Henry 2018 for a study in bias in PAS and Historic Environment Record data in Wiltshire). As with any dataset there is bias in PAS data, particularly towards metal objects. There are also gaps in the distribution maps in the areas where there are constraints to metal detecting. Therefore, with each distribution map that includes finds recorded by metal detectorists, the hard (where detecting is banned such as scheduled ancient monuments) and soft constraints (where detecting is less likely for example in woodland) have been mapped. This allows us to understand some of the gaps in the dataset, particularly Salisbury Plain.

With antiquarian and some more recent discoveries, we often lack archaeological context for the hoards. This can be an essential factor in offering new insights into the discovery. If a hoard remains in situ in the ground, we can analyse more than just the objects or the coins. Further analysis can potentially be undertaken on aspects including: the archaeological context, soil samples, samples for radiocarbon dating, pollen samples, and non-invasive archaeological surveys such as geophysical and magnetometer surveys. If, for example, a coin hoard is excavated in situ within the pot, we can understand the deposit in greater detail. From this approach, we know the Frome hoard must have been a single deposit of over 52,000 coins rather than

coins being added over a period of time, as the latest coins were not at the top. When finds are left in situ, we can also make unexpected discoveries. Within a fourth century hoard from Pewsey the bronze coins were placed within a cooking vessel. Hide (with the fur facing down) and a lead strip were placed on top before a stone was used to cover the rim of the vessel. It could therefore be argued that this hoard was deposited with the intention of recovery. Great care was also taken in concealing the deposit, which could suggest a different interpretation. The hoards considered within this book range from antiquarian discoveries where the objects no longer survive, to hoards that were excavated in situ, allowing for detailed further analysis. Each hoard offers us an insight or a new perspective on the history of the county.

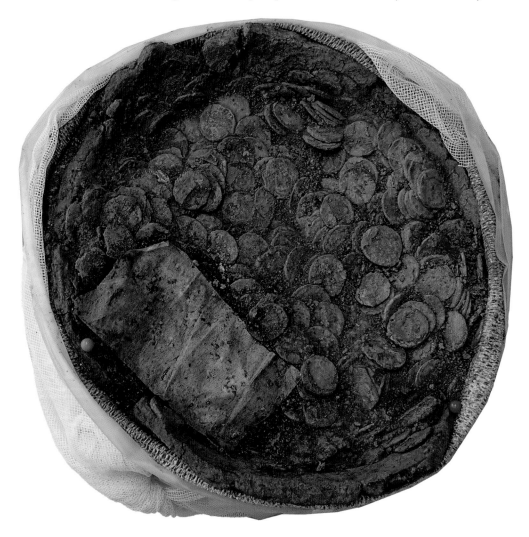

The Pewsey Roman coin hoard. (Portable Antiquities Scheme)

Ritual Deposition?

The Wardour Hoard
Period: Iron Age.
Date of deposition: 800–600 BC.
Discovered: September 2011.
Method of discovery: Metal detecting.
Contents: 114 copper-alloy objects.
Current location: On display in the Wessex Gallery in Salisbury Museum.

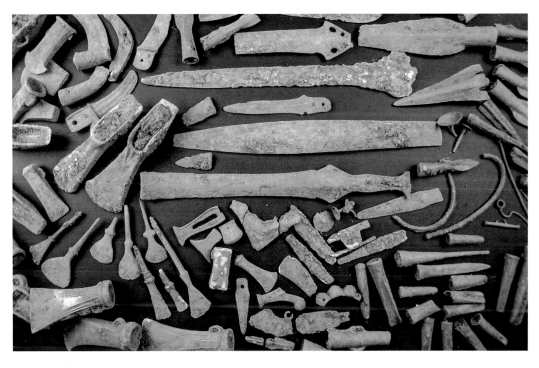

The Wardour hoard. (Dot Broughton)

The story of the Wardour hoard and its importance begins in 1985 with the discovery of the Salisbury hoard, a collection of Bronze Age and Iron Age objects. They were illegally recovered and subsequently illicitly sold all over the world. The detective work undertaken by the former Curator of the Iron Age at the British Museum, Dr Ian Stead, is published in *The Salisbury Hoard*. Through his painstaking work, it was eventually determined that over 600 objects had been deposited in a pit 30 cm wide and 45 cm deep; some of which were subsequently recovered during a British Museum excavation in 1993.

The Salisbury hoard includes miniature shields, miniature cauldrons, spearheads, rapiers, chapes, pins, axeheads, and, tools. The dates of the objects span over 2,000 years. This is highly unusual as only a small handful of hoards span such a period of time; the others are a hoard from Danebury (Hampshire), Batheaston (possibly found in the Wylye valley, Wiltshire), and potentially the hoard from Melksham. The Salisbury hoard is the largest hoard of its type from Britain. Archaeologists regularly assume that the objects within hoards are contemporary to the time of deposition. This is often the case but there are exceptions. When we consider the objects, we use in our day to day lives, their age can vary. Some have been passed down and curated or can be considered as antiques and used in conjunction with recently made objects.

It is clear that finds were made – probably while farming – of objects from previous eras and kept as they were considered important in some form. This is evident in the inclusion of Bronze Age objects as votive deposits at Roman temples. These objects were found during the Roman period and their significance recognised. They were then deposited as donatives to a god or a goddess. At an excavation of a Roman temple in south west Wiltshire, a number of Bronze Age and Iron Age objects were discovered together with significant quantities of Late Roman material. These include fragments of bronze with high tin content axes similar to those from the Hindon hoard, a barbed and tanged flint arrowhead and fragments of Bronze Age spears and socketed axes. This might also be part of the reason that we find miniature socketed axes in both Iron Age and Roman contexts from Britain as the objects were discovered, considered important and then the form copied.

Over twenty-five years after the finding of the Salisbury hoard, a metal detectorist discovered a Bronze Age spearhead, the first element of what turned out to be the Wardour hoard. They left the hoard in situ and reported the discovery to the Wiltshire Finds Liaison Officer. This meant it could be the first controlled archaeological excavation of a multi-period hoard, enabling it to be studied in minute detail. The hoard itself was arranged in layers that were 35 cm deep in total. No pit was discernible but there was a dark stain in the soil.

A late Neolithic to Early Bronze Age barbed and tanged arrowhead from a Roman temple. (Richard Henry)

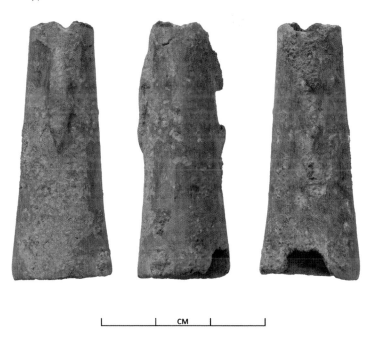

A fragment of a Bronze Age spearhead from a Roman temple. (Richard Henry)

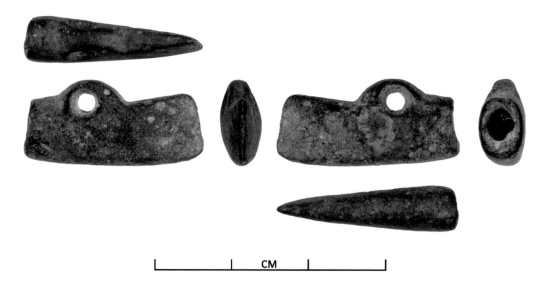

A miniature socketed axehead. (Salisbury Museum)

Left: A Bronze Age spearhead. (Salisbury Museum)

Above right: A copper-alloy sickle. (Salisbury Museum)

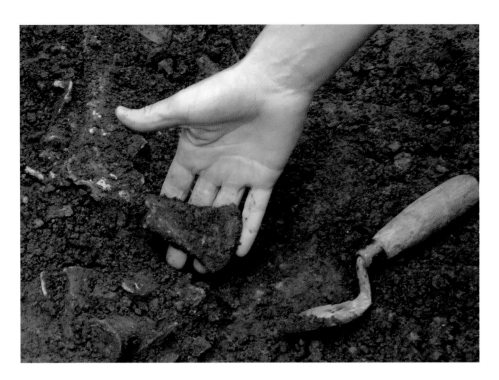

The excavation of the Wardour hoard including the Early Bronze Age flat axe.
(Salisbury Museum)

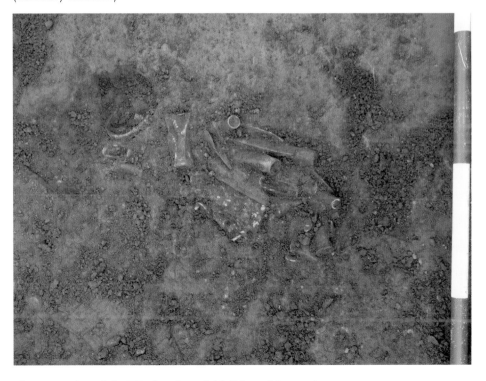

The excavation of the Wardour hoard. (Salisbury Museum)

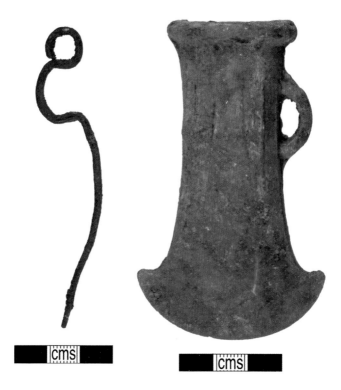

Above left: A Middle Iron Age pin. (Salisbury Museum)

Above right: A copper-alloy socketed axehead. (Salisbury Museum)

Research into the Wardour hoard has provided a unique insight into many aspects of hoarding. Crucially, the objects from the hoard span 1,400 years, from an Early Bronze Age flat axe to Middle Iron Age objects including chapes and pins. The hoard consists of 114 objects including forty-five woodworking tools and over forty pieces of weaponry. These include spears, rapiers, swords, gouges, axes, palstaves, and carpentry tools such as chisels, awls and punches.

One of the objects, a flat axe, dates from the Early Bronze Age (2200–1500 BC). The palstaves are Middle Bronze Age; the swords, rapiers and spears are Middle to Late Bronze Age; whilst the socketed axes, sickles and bag chape are Late Bronze Age. There are also Middle Iron Age chapes and pins.

The Middle Iron Age objects demonstrate a strong connection with Wiltshire and central Europe. There are dagger hilt fragments and knobbed bracelets which are rare in Britain but are more commonly found on the continent. Routes through the Wiltshire Avon and its tributaries, particularly the Wylye, to the Bristol Avon were the major transport routes during British prehistory (Sherratt 1996). The combined Avon trade axis was particularly evident up to *c.* 50 BC. Roman domination of Gaul appears to have altered the trading routes of the English Channel to a significant extent, limiting the flow of imports (Cunliffe 1991; Cunliffe 1993; Sherratt 1996).

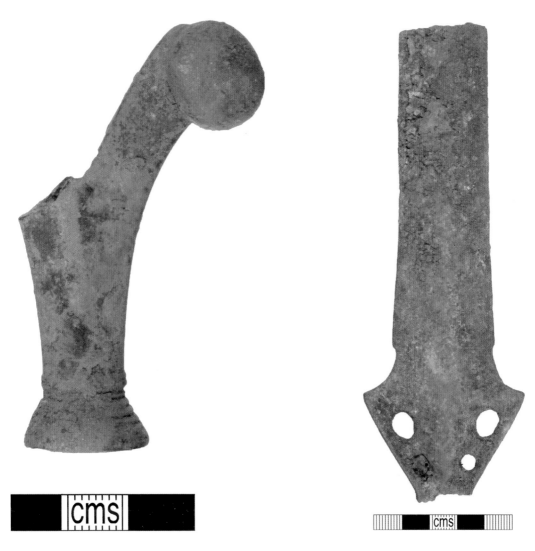

Above left: A fragment of a Continental antenna-hilted dagger. (Salisbury Museum)

Above right: A sword fragment from the Wardour hoard with evidence of textiles. (Salisbury Museum)

A number of objects from the Wardour hoard on display appear at first glance to be dirty. This is because traces of textiles remain on some of the spears and swords which have been left for future study. The initial interpretation was that they could have been wrapped or deposited in a bag. As textile was found on both the blades and the hilts of the swords, at present we cannot definitively determine if the weapons were sheathed when they were deposited.

The Wardour hoard proves that leaving hoards in situ to be excavated enables stories that might overwise have been lost to be recovered and explored. This hoard still has many stories to reveal through future research, such as the information that analysis of the textile might provide.

The Hindon Hoard
Period: Iron Age.
Date of deposition: 800–600 BC.
Discovered: December 2011.
Method of discovery: Metal detecting.
Contents: Seventy-eight copper-alloy and four iron objects.
Current location: On display in the Wessex Gallery in Salisbury Museum.

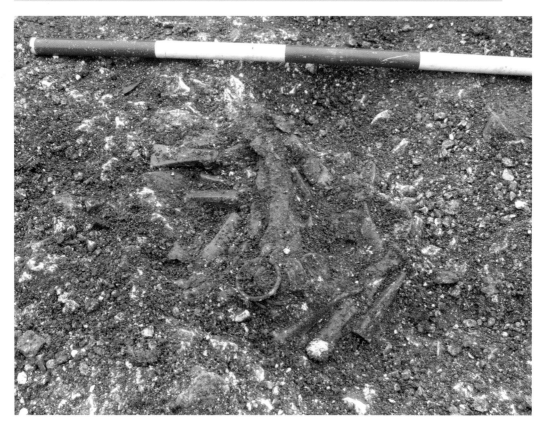

The Hindon hoard. (Salisbury Museum)

The Hindon hoard was uncovered in 2011 and left in situ by the finder, allowing it to be excavated by archaeologists. The hoard includes: thirty-four copper-alloy socketed axes, thirty-nine copper-alloy rings, sheet metal, two bracelets or bangles, three iron spears, and one iron sickle.

It is unusual for so many rings and sheet metal to be included in such hoards. The types of iron objects deposited in hoards in Britain along with copper-alloy objects is limited. From Wiltshire, iron spears were deposited in the Hindon and Melksham hoards. The only other iron sickle found in a hoard is from Llyn Fawr in Glamorgan. The Melksham and Llyn Fawr hoards were both associated with copper-alloy socketed axes, horse trappings and vessels. It has been suggested that the rings might be cauldron handles (Broughton 2015).

The iron sickle. (Salisbury Museum)

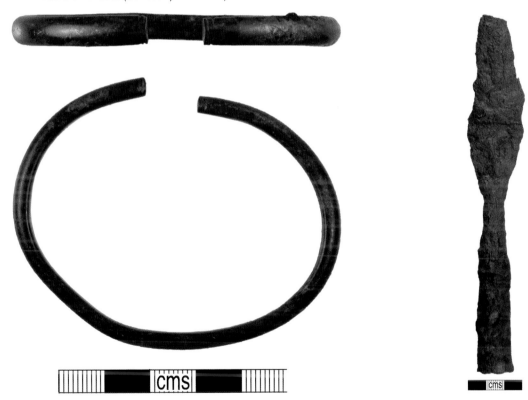

Above left: A copper-alloy bracelet. (Salisbury Museum)

Above right: An iron spear. (Salisbury Museum)

A possible cauldron handle. (Salisbury Museum)

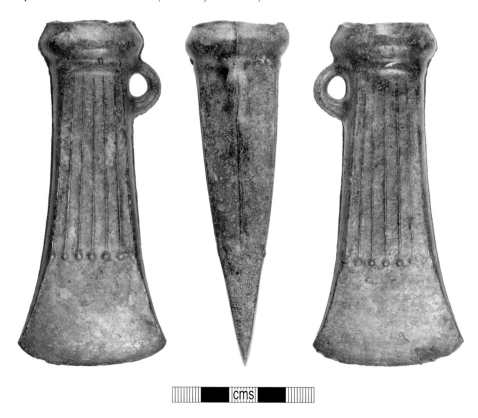

A Sompting type axe. (Salisbury Museum)

The axes from the Hindon hoard broadly fall into two groups: copper-alloy Sompting type axes, and axes with a high tin content, one of which is decorated. The plain undecorated copper-alloy axes with a high tin content are probably a new type and would have been cast in two-piece moulds (Boughton 2015). It has been suggested that this high tin content was intentional to make the axes look similar to the early iron examples. In the Iron Age, iron could not be cast. Instead it was wrought by a smith and most early iron artefacts did not have intricate moulded decoration. Early iron axes were initially produced in a similar form to the cast copper-alloy examples. The process was complex and inefficient in terms of production. Therefore, smiths soon reverted to producing iron axes with a vertical hole for the handle as is still used today.

The high tin content means that the axes are too brittle to have been useable. Indeed, all of the Hindon hoard axes are unfinished as the casting seams have not been filed down. Alternative explanations include the suggestion that they were produced for ritual functions or use as bullion. One interesting aspect is there is evidence that these unusable and unfinished artefacts have been repaired. Portable X-ray Fluorescence (pXRF) analysis, which provides information on the composition of the metalwork, revealed that one axe was damaged in prehistory and repaired with lead. If the intrinsic value of the metal was the reason for the production of these axes, it is unlikely that they would have been repaired in such a way. The bullion value would have remained whether the object was complete or not.

A further Late Bronze Age to Early Iron Age hoard was found in 2011 in the adjacent field. This consists of fragments of a range of objects including a Sompting axe fragment, a sickle fragment and casting waste. A small fragment of gold was also found in the hoard, which is unusual for the Early Iron Age, although it is more common in the Late Bronze Age. It has been suggested that this discovery was a metalworker's hoard relating to smithing in the Early Iron Age.

Hindon represents the transition from the Bronze Age to the Iron Age. Wiltshire and Glamorgan are both renowned for discoveries of some of the earliest iron artefacts. The majority have been found at settlements, such as All Cannings Cross, in middens including Potterne and East Chisenbury in Wiltshire or in hoards.

It is uncertain where the iron ore used to produce the objects was collected or smelted. Production of iron in this period was on a small scale. Before 300 BC iron was produced locally, after 300 BC smelted iron was imported as a raw material from outside Wessex. High quality iron ore is located 2 miles to the south east of the find spot of the hoard. The iron ore in the vicinity of the Hindon hoard was smelted on site during the Late Roman and medieval periods. It is possible the ore was utilised in earlier periods. Many sites show evidence for the production and working of iron and copper-alloy objects in the same location, demonstrating there was no clear distinction between blacksmiths and metalworkers.

Hoarding in prehistoric Wessex peaked in the Late Bronze Age to Early Iron Age. The Hindon hoard is a good example of this as it was most likely deposited 800–600 BC. The frequency of hoards drops off markedly in the Middle Iron Age, although we do know of some hoards such as the Chiseldon Cauldrons. Hoarding did not resume on a significant scale until a phase of iron hoarding in enclosed settlements and hillforts which occurred in the third century BC.

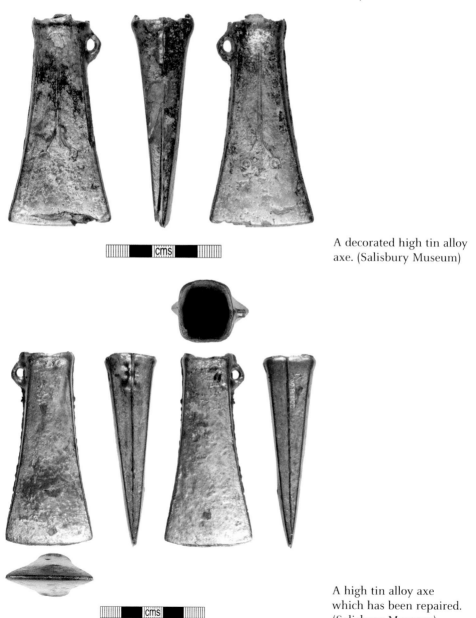

A decorated high tin alloy axe. (Salisbury Museum)

A high tin alloy axe which has been repaired. (Salisbury Museum)

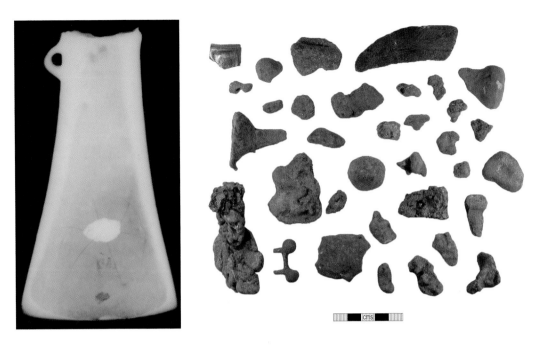

Above left: The x-ray of the repaired high tin alloy axe. (Salisbury Museum)

Above right: The metalworkers hoard. (British Museum)

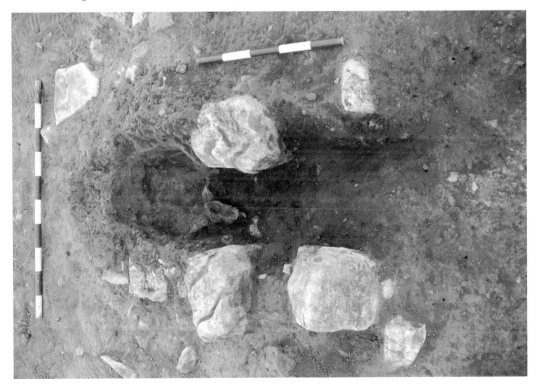

A Late Roman furnace. (The Past Landscapes Project)

The Chiseldon Cauldrons
Period: Iron Age.
Date of deposition: 400–200 BC.
Discovered: November 2004.
Method of discovery: Metal detecting.
Contents: Seventeen cauldrons.
Current location: On display in Room 50 at the British Museum.

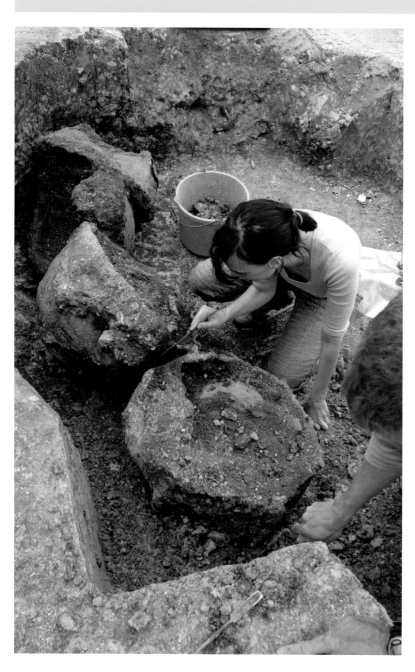

The Chiseldon cauldrons being excavated by Wessex Archaeology and the British Museum. (Wessex Archaeology)

This hoard was discovered by Pete Hyams in November 2004 when he uncovered pieces of bronze sheet. An initial trial excavation revealed two more crumpled objects. The importance of this discovery was not fully understood until Pete Hyams asked Peter Northover at Oxford University to undertake metallurgical analysis. This highlighted that the objects were Iron Age. Wessex Archaeology and the British Museum subsequently undertook an excavation in the summer of 2005 (See Baldwin and Joy 2017).

The excavation revealed eleven almost complete copper-alloy and iron cauldrons within a pit 2 m in diameter and 65 cm deep. The majority had been deposited around the wall of the pit in layers. In the northern section of the pit, the cauldrons were stacked four deep. The cauldrons were removed in large soil blocks. The hoard was declared Treasure and ultimately acquired by the British Museum. The cauldrons were then excavated from their blocks over a period of four years.

During the excavation of the soil blocks at the British Museum, a further six cauldrons were discovered bringing the total to seventeen. This made the hoard the largest known single deposit of cauldrons in Britain. Radiocarbon dating revealed that the hoard was deposited in the fourth or third centuries BC, pushing back the potential date for such cauldrons by over 100 years. Unlike most Iron

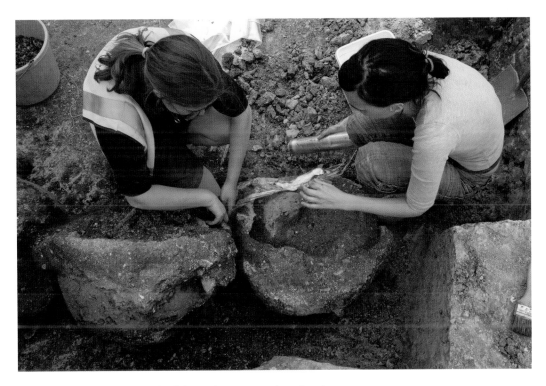

Preparing the blocks for lifting. (Wessex Archaeology)

Age examples, there are elements of decoration on some of the cauldrons, and manufacture marks and repairs are also well-preserved.

The cauldrons range from 560 mm to 310 mm in diameter. They are all of composite construction and have been made from iron and copper-alloy sheet riveted together. The majority were constructed in four main sections: the rim, the iron band, the copper-alloy band and the bowl. As the copper-alloy sheet is only between 0.2 mm and 0.5 mm thick, they are relatively flimsy. Therefore, when not in use, they were likely stored upside down. A number of examples have been repaired with patches at points of stress. This suggests they were used for a prolonged period of time, rather than made specifically for deposition. However, not all of the applied patches are due to repairs being required. Eight cauldrons have decorated patches which appear to have been applied at the time of manufacture.

Metallurgical analysis of the iron and copper-alloy offers further insights into the production of the materials used in manufacture. The copper-alloy is a tin bronze with low levels of impurities. Critically, it contains less than 1 per cent lead. This is important because although lead is used in alloys for casting, it is difficult to work

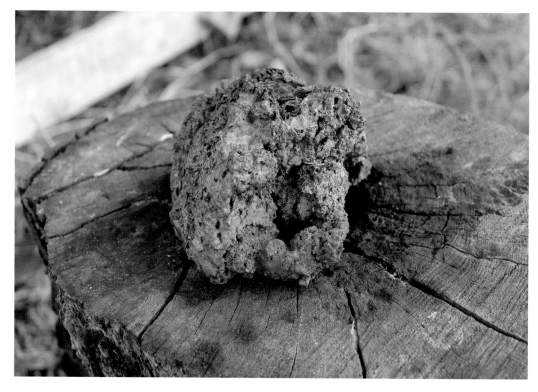

An iron bloom from smelting. (Richard Henry)

in sheet form as it is insoluble in copper. The production of the copper-alloy bowls takes the metal to its limits as all the sheet metal is less than 0.5 mm thick. The composition of the alloy suggests that the copper-alloy was probably of southern British origin. The metal analysed on a group of cauldrons suggests that most of the iron for each individual cauldron was produced from a single or similar iron bloom (the raw material after smelting) from the same iron ore. But the iron from the different cauldrons analysed appears to have been constructed from iron blooms from different sources made at different times, rather than a single source. The use of quenching where the wrought iron was rapidly cooled in water to fit the rim to the iron band is one of the techniques developed by smiths in the Iron Age.

The analysis of food residues from the vessels show they were used to prepare both meat- and vegetable-based dishes; the largest cauldrons from the hoard could hold over seventy litres. The fatty residues and soot deposits which survive show they had been used for cooking prior to deposition, not just for storage.

The quantity of cauldrons and their size highlights the potential in the period for feasts which would host hundreds of people. Feasts are a communal act which

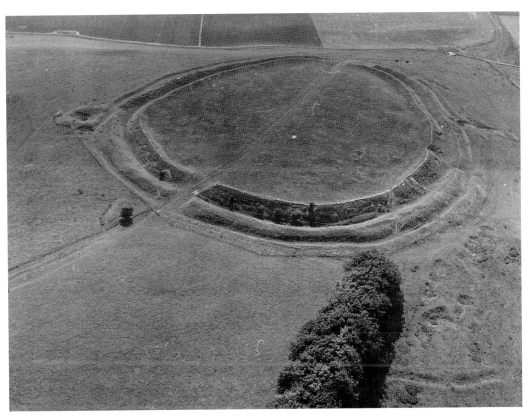

Barbury Castle. (Wiltshire Council Archaeology Service – AER 981 Oblique 24/08/78)

brings together hundreds of people and require extensive planning. Religious acts at the time were probably communal rather than dominated by powerful individuals. The evidence therefore strongly suggests that the vessels were made for feasting and that the deposition of the hoard is perhaps representative of a large feast, or series of feasts, rather than the physical remains from an event. This is because other items required for a feast such as cauldron chains and extensive animal remains were not deposited within the pit.

The geophysical survey of the site where the cauldrons were discovered revealed pits, evidence for structures and field boundaries as well as enclosures. These were interpreted as mostly being Roman in date. The hoard was deposited on the undulating land below the Marlborough and Lambourne chalk downland. The find spot is located to the north of The Ridgeway and the River Og. The Barbury Castle and Liddington Castle hillforts are each side of the valley of the River Og and overlook the find spot. A further hillfort has been identified by aerial photography near to Chiseldon.

The hoard was deposited in a period when some hillforts in Wessex were being remodelled, while others were falling out of use. The first defenses at Liddington were constructed in the Early Iron Age, with the timber rampart being succeeded by a dump type rampart in the fifth–fourth centuries BC. It has been suggested that the fort was abandoned by the end of the fourth century BC. In contrast, Barbury Castle remained densely populated and is regarded as a Middle Iron Age developed hillfort where modifications were undertaken around the time of the deposition of the hoard. A hoard of ironwork was also recovered from near Barbury Castle which includes reaping hooks, spearheads and knives. It has been suggested that the hoard dates from the Late Iron Age to Roman period (Manning 1972).

Sherratt (1996) argues that both hillforts and oppida dominated and controlled inter-regional routes of traffic and trade, as well as their own immediate blocks of land. Prime examples are the hillforts of Scratchbury and Battlesbury, which dominated the Wylye valley. Hillforts are seen as being symptomatic of economic articulation and the flow of goods in a 'down the line system' as well as defensive structures (Sherratt 1996).

Overall, the evidence suggests that the Chiseldon cauldrons were constructed at different times and used for a prolonged period of time prior to deposition. They were used for the preparation and serving of food at feasts. The hoard has been interpreted as a representation of a feast or a number of feasts. The capacity of the cauldrons supports this suggestion of large social gatherings. The hoard might have been deposited close to the Ridgeway to make it easily accessible to different communities and groups.

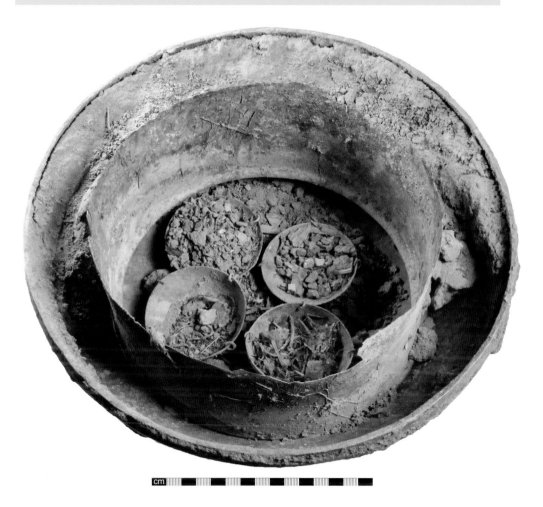

The Pewsey hoard. (Salisbury Museum)

The Pewsey hoard was discovered in October 2014 and was removed from the ground by the finders. As it was left as a structured deposit and, crucially, not cleaned, it was possible to undertake detailed scientific analysis. The find spot was excavated in January 2015. The hoard consists of three vessels and four weighing scale pans concealed within an iron-rimmed cauldron. As each vessel was made out

of bronze, the find did not classify as Treasure under the Treasure Act, although it is arguably one of the most exciting hoard discoveries from Wiltshire.

Cauldrons are often associated Iron Age feasting and around thirty iron rimmed cauldrons are known in Britain. The Pewsey cauldron was constructed using a high tin bronze less than 5 mm thick and when produced it would have been visually striking. There was soot on the base of the cauldron showing that it had been used. It is probable that, like the examples from Chiseldon, it would have been stored upside down when not in use. Similar Late Roman cauldrons have been found in hoards from Wotton, Surrey and Burwell, Cambridgeshire.

The three vessels consist of a bowl (which might possibly have been an antique when deposited), a vessel with three scallop shaped feet and an Irchester bowl. As with the cauldron, the bowl also had soot on the base. Irchester bowls are basins manufactured in the fourth or fifth centuries in Britain. Their uniformity suggests they were produced in one central (or associated) workshop. They are often found with cauldrons in hoards, four have been recorded from Wiltshire: the Pewsey hoard, the Wilcot hoard, the Bishops Cannings hoard and an example discovered in 2018 in Lacock.

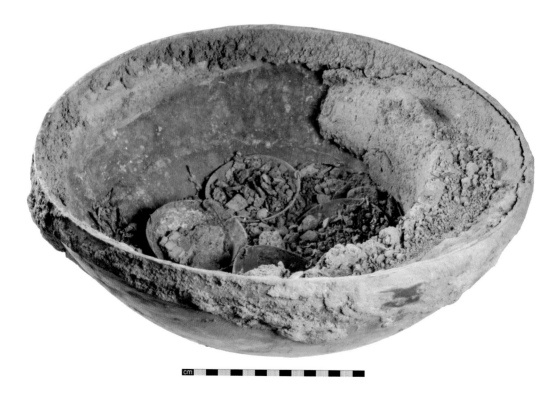

The Irchester bowl and four scale pans. (Salisbury Museum)

The scale pans form two sets and are unparalleled in Late Roman hoards. They were used with an equal balance or a dual balance and would have been used to weigh small quantities of goods. As no scale arms, chains or weights were deposited within the hoard, this could suggest that by the time of deposition the pans were being used for a different purpose or the remaining elements were deliberately excluded.

The hoard formed a structured deposit; each vessel in turn was deposited within another, similar to Russian dolls. Many structured deposits formed of copper-alloy vessels are recorded as having been deposited with the vessels nestled within one another, such as the Irchester and Wilcot hoards. Given how the cauldron probably was stored upside down when it was not in use, its position facing upwards could be significant.

The structured deposit created a micro-climate, leading to the preservation of organic remains and pollen in the centre. These include black knapweed, vetch, clovers, grasses, buttercups, docks, and, bracken (Henry et al. 2019). The organic material has been radiocarbon dated to between AD 340/405. The discovery of such well-preserved organic material from a hoard is staggering in its own right, yet analysis is able to provide further unique insight.

The pollen analysis highlights three distinct pollen assemblages associated with the hoard, enabling us to understand where the hoard was packed, stored and finally deposited. The first assemblage is associated with the organic material used to pack the hoard. The hoard was then stored in a location within open grassland, before finally being deposited in an arable field immediately after the cereal harvest in late summer or early autumn. It is highly unusual that we can date the deposition of a hoard to this level of detail. The organic material includes spelt – the classic wheat for the Roman period.

When combined, these elements create an unusual narrative of the very end of the Roman period and the early post-Roman period. The vessels were deposited within close proximity of two kilns, and two potential villas. At the Stanchester villa, 3 km to the west, the Wilcot hoard of a similar date was discovered, as well as a significant Late Roman coin hoard.

The Pewsey vessels are definitively Roman in form and archaeologists often associate cauldrons with feasting. Both this and the Wilcot hoard include objects which have probably been curated. Pewsey was deliberately deposited with specifically chosen plants as packing material. Unusually, because of the pollen analysis we can infer that the hoard was deposited in a separate location to where it was packed and stored. The Pewsey (as well as the Wilcot and Stanchester hoards) therefore provide an insight into the late fourth and early fifth centuries when the landscape and society of Britain were on the cusp of major changes.

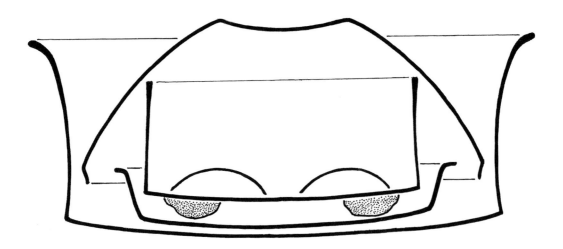

The structured deposition of the hoard. (Nick Griffiths)

Knapweed (*Centaurea sp.*) flowers. (Historic England)

Bracken
(*Pteridium
aquilinum*)
pinnule tips.
(Historic England)

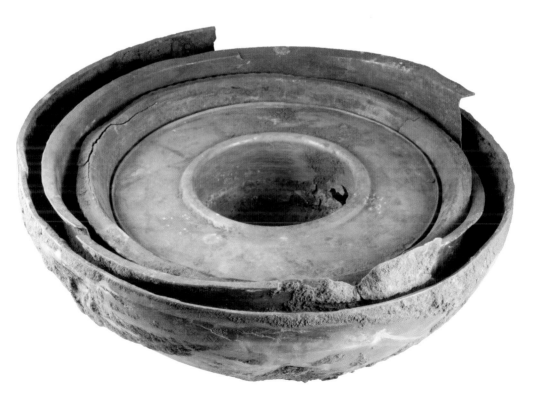

The Wilcot vessel hoard. (Salisbury Museum)

The Kingston Deverill Hoard
Period: Roman.
Date of deposition: AD 43–150.
Discovered: February 2005.
Method of discovery: Metal detecting.
Contents: Five copper-alloy vessels.
Current location: On display in the Wessex Gallery in Salisbury Museum.

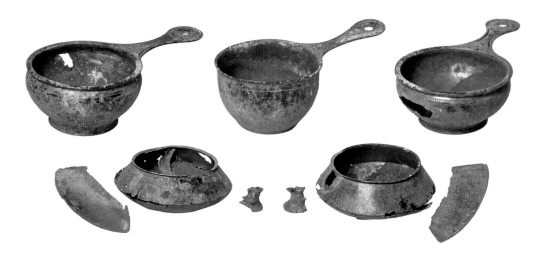

The Kingston Deverill hoard. (Salisbury Museum)

The Kingston Deverill hoard was discovered in 2005 and left in situ, allowing the hoard to be excavated by Wessex Archaeology. The hoard consists of three copper-alloy *trullei* (saucepans) and two copper-alloy wine strainers. As the hoard does not constitute Treasure the finder and landowner sold it privately to Salisbury Museum. Two of the *trullei* were produced in Italy and one in Gaul, whilst the wine strainers were made in Britain. Italian and Gallic bronze smiths were noted for their products, particularly *trullei*. One *trulleus* has the maker's stamp of Publius Cipius Polibius, a well-known producer of *trullei* during the first century AD in the region of Capua, near Pompeii. The workshop of Cipius Polybius was most active *c.* AD 65–85. Of the finds in Britain that were made by Publius Cipius Polibius, nine come from the northern frontier and Hadrian's Wall. This example is a marked outlier from the distribution pattern (Worrell 2006).

The hoard was analysed using a pXRF which provided information on the composition of the metalwork. Each *trulleus* is constructed from a richly tinned bronze, whilst the wine strainers are a leaded tin rich bronze. Interestingly, one *trulleus* has been repaired using an easily manipulated alloy of highly leaded bronze. When evaluating the finds on the PAS from the environs of the hoard, no other objects, including a wide array of Late Iron Age and Roman brooches, show any sign of repair after breaking. This repair on the *trulleus* is therefore

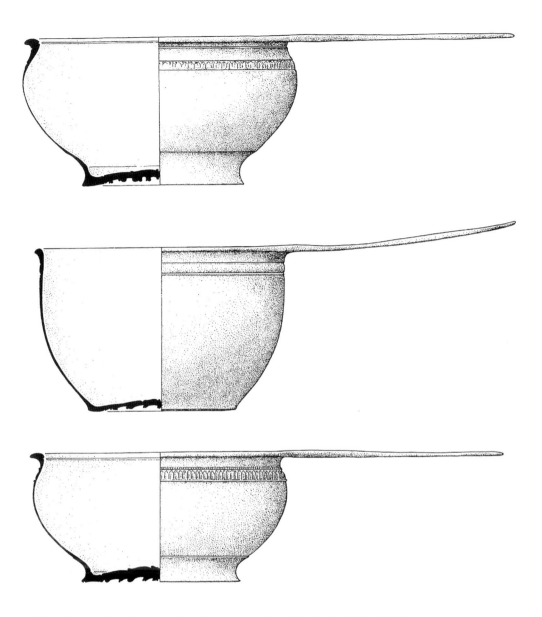

The three *trullei*. The central *trullius* was produced in Gaul. (Nick Griffiths)

inconsistent with the wider evidence of a lack of repaired metalwork in the area. Unlike Roman brooches, which the evidence suggests were in regular supply as they are not repaired when broken, such Italian metalwork would be significantly less readily available and therefore repaired rather than replaced when damaged.

The wine strainers, which are also a rare find, are a native British product. It has been argued that the wine strainers are linked to the consumption of beer and possibly mead rather than used for wine (Sealey 1999). The spouts of the wine strainers depict beasts and one have a lid decorated with two ducks. Wine strainers are known from hoards of high-status Iron Age metalwork as well as Early Roman burials.

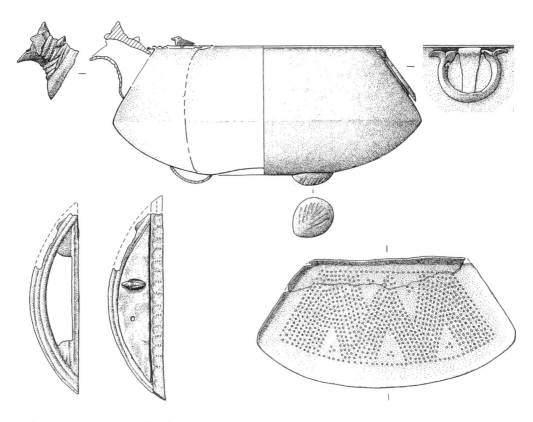

A wine strainer. (Nick Griffiths)

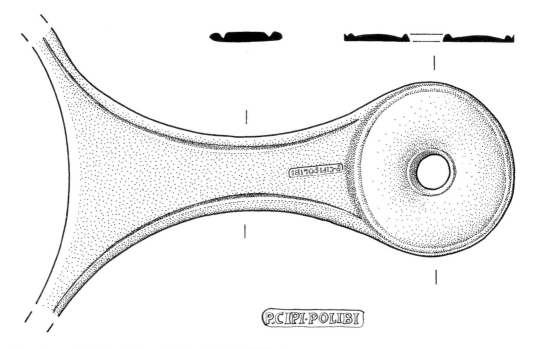

P.CIPI·POLIBI

The stamp of Publius Cipius Polibius. (Nick Griffiths)

The hoard raises a number of interesting questions. Many *trullei* produced by Publius Cipius Polibius are found on the northern frontier. No other example has been recorded from the south west, an area which it has been argued was isolated in the Late Iron Age (Van Arsdell 1989, Cunliffe 1991). So why might it have been deposited here? As the hoard was left in situ, we are able to understand how the hoard was structured. Each vessel was deposited upside down and the handles of the *trullei* were facing to the south and the spouts of the wine strainers were facing north. This is in the directions of the two main Iron Age tribes in Wiltshire, the Durotriges and the Dobunni. The hoard was discovered within a square enclosure to the south of an Iron Age tribal boundary. It is also in close proximity to swathes of field systems and two Roman temples as well as Neolithic long barrows and Bronze Age round barrows. The structure of how the hoard was buried – together with where – has led to the suggestion that it was a ritual deposit.

Some of the key themes in the Late Iron Age in Wiltshire, particularly in the area defined as Durotrigan, are retraction, isolation and interaction. The theme of isolation in the Late Iron Age is regularly highlighted in archaeological literature (Van Arsdell 1989, Cunliffe 1991). However, the quantity of Iron Age and early

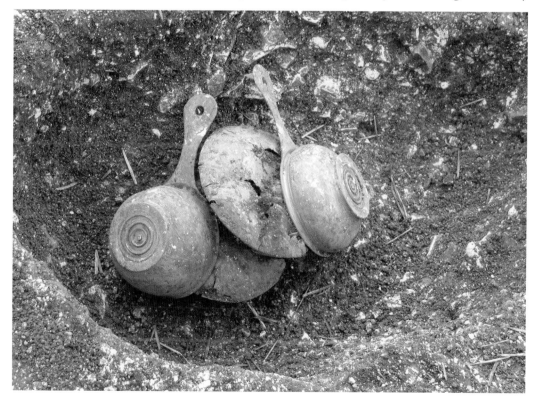

The hoard in situ. (Salisbury Museum)

Roman coins from the environs of the hoard, the hoard itself and unusual artefacts, such as a fragment of an Irish Y-shaped yoke fitting (the first to be recorded in Britain), certainly hint at a landscape that was not isolated. Instead, therefore, we should consider this landscape as vibrant. The datasets suggest a wide range of trade networks which increase dramatically in the Roman period. The assemblages of coins and artefacts from the environs also imply settlements and sites of some local significance, potentially in relation to the tribal boundary, which change substantially in the Roman period.

Prior to the Roman conquest, the range of ceramics and other artefacts was primarily (but not exclusively) limited to what could be produced locally. After the invasion, it is more common to find imported goods such as pottery and metalwork. This change reflects the increased availability of consumer goods and the ability to acquire such objects. The Kingston Deverill hoard and the Irish yoke fitting both highlight interaction rather than isolation. Both are located to the south of the suggested Iron Age tribal boundary of the Durotriges and the Dobunni which is defined along the river Wylye. Is the tribal boundary a key factor in the choice of location for the deposition of the Kingston Deverill hoard?

Roberts (2014) notes that shared consumption at a place of ritual significance, located on the border between communities, could have been a suitable way of marking resolutions. In the Late Iron Age, feasting becomes a more prominent social practice and in the Roman period there is evidence in ritual deposits of wine consumption (Van der Veen 2007). The specific alcoholic beverages consumed using these high-status wine strainers has been questioned, yet the evidence of

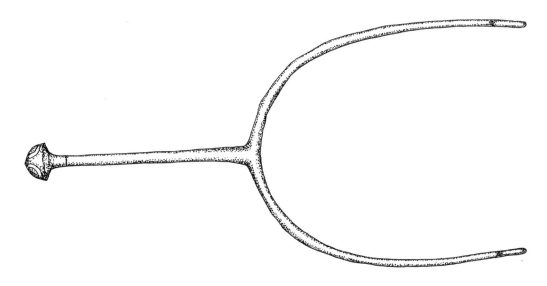

A complete Y-shaped yoke fitting. (Claire Goodey)

consumption in ritual deposits and feasting should be considered as significant elements for the deposition of the hoard. The proximity to two Roman temples and Bronze Age barrows could also be seen as significant. The location of the hoard within a defined enclosure directly to the south of a tribal boundary. The structured deposit and the evidence for shared consumption at boundary locations does strongly suggest we should consider the possible ritual significance of this hoard.

The combination of significant trade routes in the vicinity and shared consumption, with the discovery of Dobunni silver coins to the south of the tribal boundary as well as Italian, Gallic, British and Irish metalwork, is an interesting example of interaction and trade. This hoard highlights the well-developed trade networks which would become further developed in the Roman period.

A copper-alloy fragment of a Y-shaped yoke fitting. (Salisbury Museum)

Multiple Hoards from A Single Site

The Manton Hoards
Period: Roman.
Date of deposition: AD 300–410.
Discovered: 1883 and 2013.
Method of discovery: Landscaping work and metal detecting.
Contents: Twenty-six silver coins, fifteen pewter vessels, eighteen iron objects and a lead panel from a tank.
Current location: Wiltshire Museum, Devizes (in part).

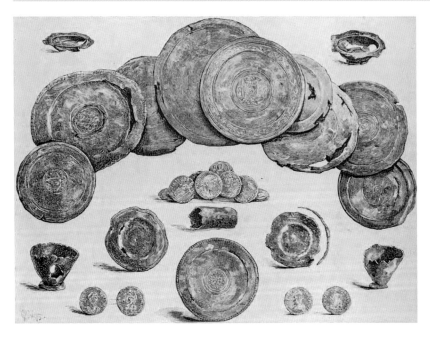

The Manton pewter and coin hoards discovered in 1883. (*London Illustrated News* 1884)

Since 1883, a number of significant Late Roman discoveries have been recorded in Manton near Marlborough. The initial finds in 1883 consisted of a coin hoard of Late Roman silver *siliquae* and a hoard of Late Roman pewter vessels found a few days later. In recent years, discoveries in the same field have included a Late Roman hoard of iron tools recorded in 2013 and a mutilated panel from a lead tank or font in 2018. The panel is perhaps associated with the pewter hoard as there are other examples of tanks in hoards of pewter. All of the Manton hoards are fourth or fifth century in date. The number of hoards, as well as the presence of the panel from a tank, raise interesting questions as to why they were deposited in this location.

The coin hoard consists of twenty-six late Roman silver *siliquae* which were deposited after AD 393. From the surviving evidence, it is unclear if the silver coin hoard and pewter hoard were directly associated, or if it was coincidence that they were discovered a few days apart. When they featured in the *London Illustrated News*, they were placed together. The pewter hoard consisted of at least ten to twelve dishes, three cups, two bowls and a pewter tube (Peal 1967).

The pewter hoard was deposited in the fourth or fifth century. Bowls, plates and dishes are known through the duration of Roman Britain, but date predominantly to the fourth century (Lee 2009). In contrast, cups are largely restricted to the mid-fourth–fifth centuries. The two surviving bowls have octagonal rims. Moulds for making octagonal rims such as these were found 20 miles away at Nettleton Scrubb near Chippenham. The suggested date of the Manton pewter hoard was derived from the date of the coin hoard. Although the Pewter hoard and coin hoard were found in close proximity a few days apart, an earlier fourth century date should not be ruled out given the lack of context recorded in the antiquarian report.

There is a concentration of pewter finds and moulds in the region of the Mendip Hills, Somerset. The Mendips were an important source of lead and silver in the Roman period. The silver was extracted from the lead through the process of cupellation. In the Iron Age, lead extraction was limited. After the Roman Conquest there was increased production and for a time it appears it was an Imperial monopoly. Lead was widely exported after the invasion, and significant structures, such as bath sites, required considerable quantities. Moorhead (2001) suggests that the Roman road running through the region from the south coast to the Mendips may have acted as a distribution route for coinage. Indeed, there are significant quantities of Late Roman silver coin hoards in the south west.

The iron hoard discovered in 2013 consists of eighteen objects. We know of only approximately forty ironwork hoards from Roman Britain, the majority of these date from either the first century or the fourth century AD. Hoards from the first century are usually associated with the military, whereas many of the fourth

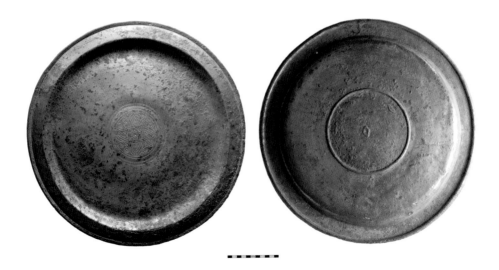

A pewter dish. (Richard Henry)

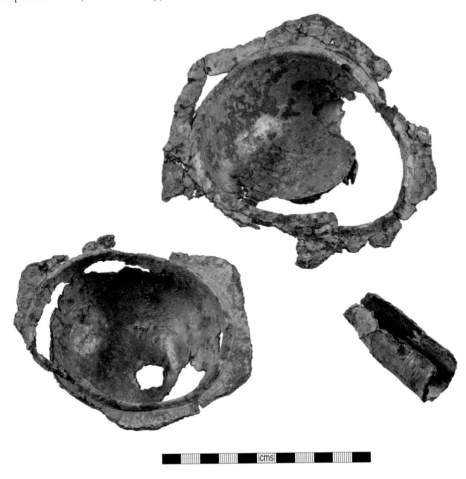

Two pewter bowls and a pewter tube. (Richard Henry)

century hoards consist of agricultural implements and tools. The Manton hoard is likely to date from the fourth century as it includes: a bolt padlock, chisels, knives, and, a mowers anvil (a portable anvil used to sharpen scythes). Both the scythe and the mowers anvil were Roman introductions. It required significant skill to produce such artefacts as all Roman iron was wrought and was therefore produced by a blacksmith.

It has been argued that Roman ironwork was a highly symbolic medium and was probably deposited for religious or ritual motives (Hingley 2006). By the Late Roman period, there had been a shift towards depositing iron in deep pits and wells. Iron hoards may not be closed deposits made at a single point in time. Instead, they could have been built up gradually and used as a way to store resources. In a similar way to the discussion of some coin hoards as 'savings hoards'. Unfortunately, as the hoard was not left in situ, we are unsure of the archaeological context. Generally, from the second century onwards the number of iron hoards from wells and pits increased, while the number of those from boundaries decreased (Hingley 2006). The hoard from Jordan Hill, Dorset, was found in the bottom of a votive shaft under ashes, stones and bird bones. The two hoards from Silchester, Hampshire, were found in a pit (the 1890 hoard) and a well (the 1900 hoard).

Most recently, the incomplete side of a decorated Roman lead tank or font decorated with a phallic motif was recorded in Manton in 2017. The panel of the tank was mutilated by being stabbed from both the front face and the back and it was then folded pre-deposition. It has subsequently been unrolled and flattened post-recovery. The tank was donated to the Wiltshire Museum, Devizes.

When these hoards are considered as a whole, their quantity and date strongly suggest a location of significance. The distribution in Britain of bronze vessel hoards, pewter hoards and iron hoards is strikingly similar and it has been suggested that they are in some way connected (Manning 1972). Unfortunately, nothing is known of the archaeological contexts of any of the discoveries from Manton and therefore we can only infer potential reasons for their deposition. There is a strong theme of ritual deposition in academic discussion and the archaeological context of iron hoards, pewter hoards and the lead tanks. Therefore, as individual hoards there might be an argument for some form of ritual deposition. This could be further supported if we had evidence of how they were discovered, if for example they had been found in a deep pit.

Usually such finds are considered by specialists in isolation, one single deposit could be important and evaluated, but could the three combined signify some kind of settlement and associated activity instead? It had previously been suggested that, given the coin hoard and pewter hoard, there was a potential link between

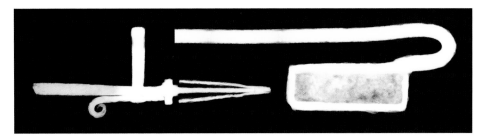

An iron bolt padlock. (Salisbury Museum)

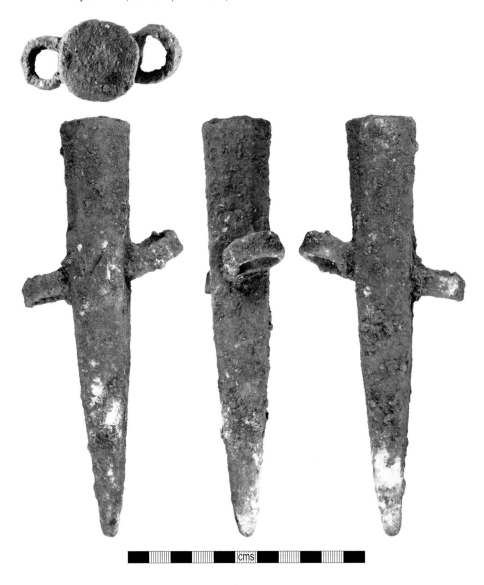

An iron mowers anvil. (Salisbury Museum)

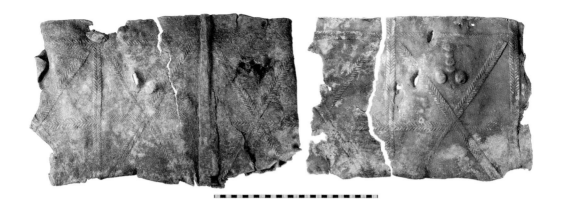

The lead panel from a tank. (Salisbury Museum)

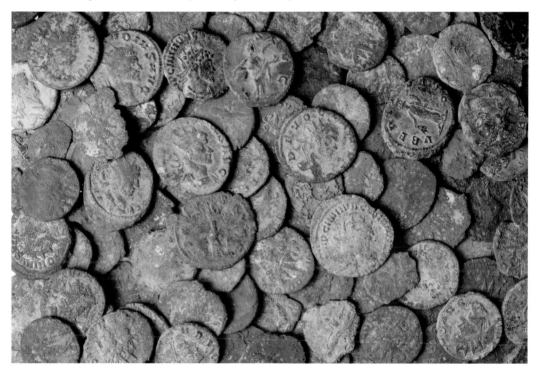

The third-century Roman coin hoard from the adjacent field. (Salisbury Museum)

the hoards and a nearby villa at Barton Down (Hostetter and Noble Howe 1997). The addition of further discoveries (and a third century radiate hoard in the adjacent field) does suggest that there might be a link between the hoards and the nearby villa.

The Bowerchalke Iron Age Coin Hoard and Roman Hoard
Date of deposition: *C.* 60 BC and after AD 395.
Discovered: 1990–95.
Method of discovery: Metal detecting.
Contents: Sixty-two Iron Age coins and sixty-six Roman coins and four gold rings.
Current location: On display in the Wessex Gallery in Salisbury Museum.

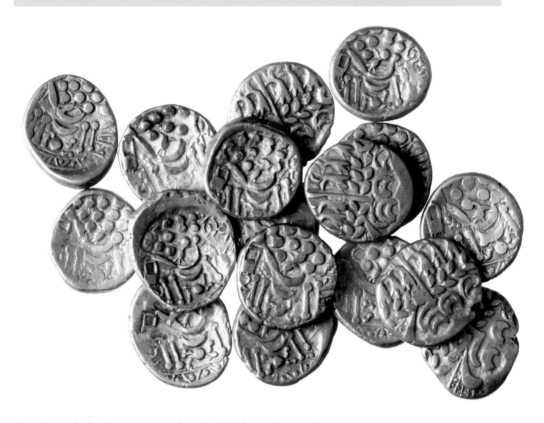

The Bowerchalke Iron Age coin hoard. (Salisbury Museum)

Over the course of six years sixty-two Iron Age gold and silver staters were discovered in a field in Bowerchalke. The first group of seventeen gold British B (Chute) staters was found between October 1990 and March 1991. Chute staters were produced by the Durotriges around 80–60 BC. The coins were acquired by Salisbury Museum after being declared Treasure Trove. Between September 1991 and 1995 a further twenty-nine gold staters were found.

Nearby, a group of thirteen base silver Durotrigan staters dating from 58 BC–AD 43 and three gold staters of Verica, the King of the Atrebates, dating from AD 10–40 were found. The latter group was not declared Treasure Trove as they were considered stray finds not associated with the original hoard due to them being dispersed over *c.* 100 m. If the group had been found after 1997 with the revised Treasure Act, they probably would have been declared Treasure as a separate

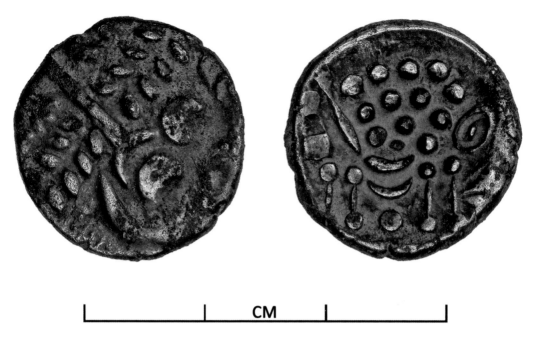

A similar stater to the debased silver examples from the second hoard. (DOR-5A6C90 – Dorset County Council)

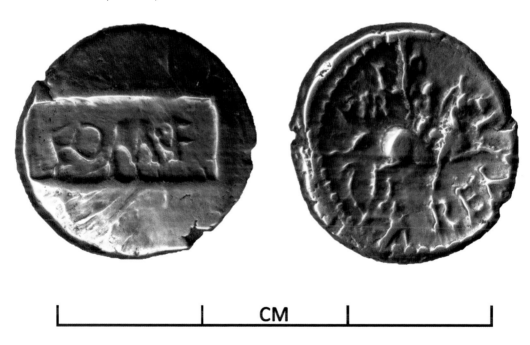

A similar stater of Verica. (DOR-A3D5C3 – Dorset County Council)

group. Recent research has highlighted that hoards can be dispersed over 130 m (Henry and Algar 2018).

The Durotriges are seen as a close-knit confederacy of smaller units and Cunliffe (1991) suggests their history can be traced in two phases, 100–60 BC and 60 BC–AD 43. The years 100–60 BC were a period of rapid development whilst 60 BC–AD 43 is traditionally seen as a period of retraction and isolation (Cunliffe 1991). These two hoards fall under both phases. The gold coinage and the later silver and copper-alloy coins have been mapped against the tribal boundaries suggested by Eagles (2018). Van Arsdell (1989) argues that by *c.* 54 BC the Durotriges struck only silver coins. Subsequently though, in the first century AD, bronze issues were struck. The Durotriges may have chosen to mint silver coins rather than gold due to a lack of gold or to bring the tribe in line with continental trade links (Van Arsdell 1989).

As highlighted when discussing the Wardour hoard, the River Avon (located to the east of Bowerchalke) was a key trade route in prehistory. The port of Hengistbury Head, Dorset, was probably part of a currency-based trade route by 125 BC and the most important British port until *c.* 50 BC. Imported goods from the excavations at Hengistbury Head include amphora, blocks of raw purple and yellow glass, and, figs demonstrating the import of high-status goods from mainland Europe to the region. Exported items include iron, copper-alloy, gold, silver, shale, and grain (Cunliffe 1991; Cunliffe 1993).

When the Iron Age coins from Bowerchalke were reported, further finds from the Iron Age and Roman periods were also recorded from the same site. Over the years, at least 1,200 coins and artefacts have been recorded, providing evidence of continued activity from the Late Iron Age to at least the end of the Roman period. Taken together, the finds suggest that the hoard was deposited in close proximity or within a rural settlement of some kind.

As with the Iron Age coin hoards, the components of the Late Roman hoard from Bowerchalke were found over a number of years and include: four gold finger rings, one gold *solidus*, four silver *miliarense* and sixty-one silver *siliquae*. *Miliarense* are unusual as site finds and tend to occur more regularly in hoards. This is because they are high-value coins which are often deliberately removed from circulation. *Siliquae* are more common as site finds, particularly at rural sites, but are also found in hoards. Each of the silver coins are struck with a mint mark which ends in PS (*pulsatum*) indicating that the coin is of a high purity. OB (*obryzum*) signifies the same high purity for gold coinage. The gold *solidus* is of the emperor Valentinian II (AD 388–92). It has been suggested that the disposable income for a Roman soldier per year around AD 400 would be two gold *solidi*. It is clear therefore that in coinage alone this hoard would be of significant value, even before the inclusion of four gold rings.

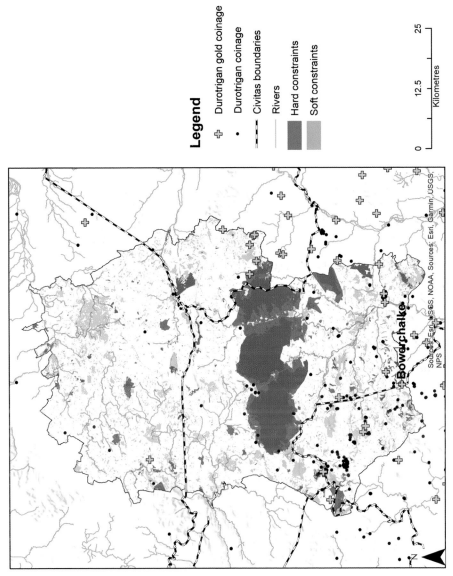

Legend

✛ Durotrigan gold coinage

• Durotrigan coinage

╌╌ Civitas boundaries

─── Rivers

▓ Hard constraints

▒ Soft constraints

0 12.5 25
Kilometres

Bowerchalke

Sources: Esri, USGS, NOAA, Sources: Esri, Garmin, USGS, NPS

Distribution of the Durotrigan coinage mapped against the tribal boundaries suggested by Eagles (2018) and areas where metal detecting is banned (hard constraints) or unlikely (soft constraints) in Wiltshire. (Richard Henry)

A silver *siliqua* of Gratian. (Salisbury Museum)

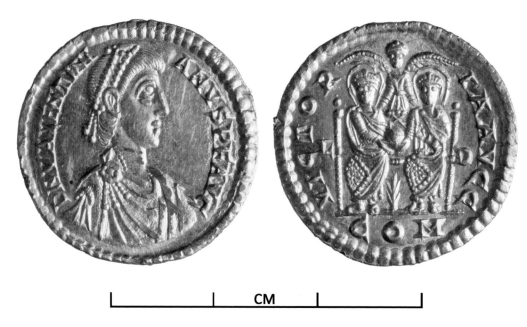

A gold *solidus* of Valentinian II. (Salisbury Museum)

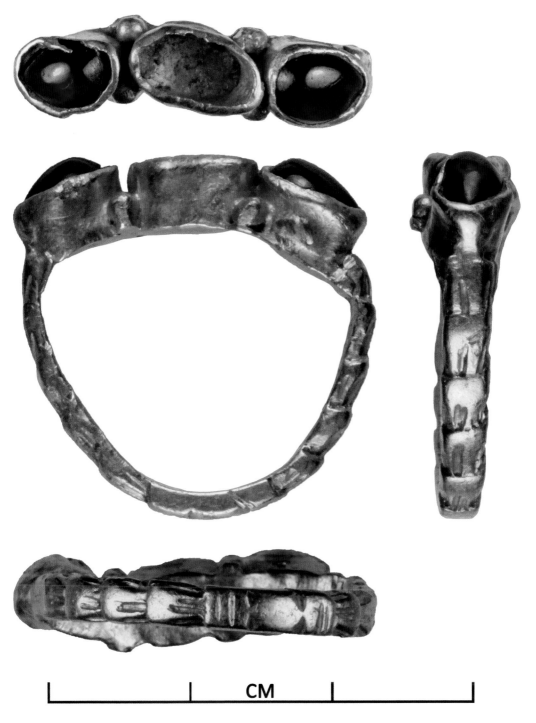

A gold ring with garnets. (Salisbury Museum)

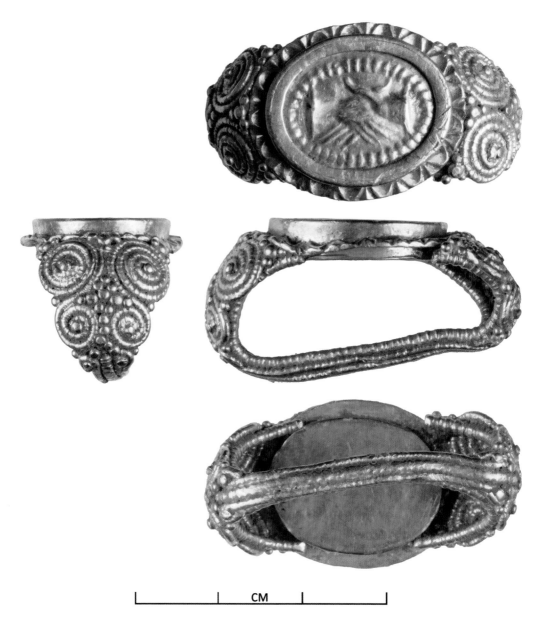

A gold finger-ring with clasped hand iconography, the band is produced from filigree.
(Salisbury Museum)

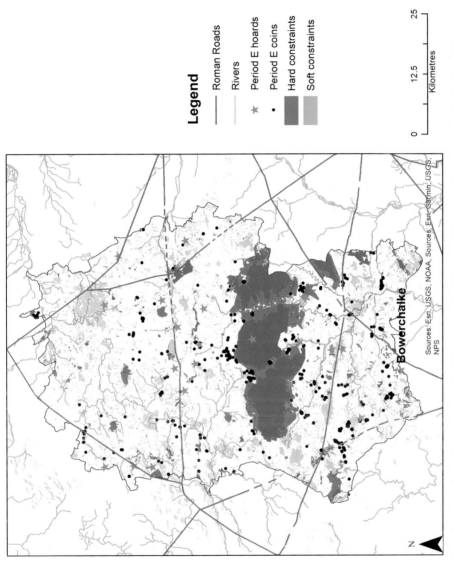

Distribution of coin hoards deposited between AD 364 and 402 mapped against single finds of the same date and areas where metal detecting is banned (hard constraints) or unlikely (soft constraints) in Wiltshire. (Richard Henry)

Legend

—— Roman Roads

—— Rivers

★ Period E hoards

• Period E coins

▨ Hard constraints

▨ Soft constraints

Bowerchalke

Sources: Esri, USGS, NOAA, Sources: Esri, Garmin, USGS, NPS

0 12.5 25
Kilometres

The first ring to be discovered by the metal detectorists contained garnets within the bezel. The remaining three rings are decorated with clasped hands. One of the other finger rings has been constructed solely using the technique known as filigree, with intricate spirals formed from small grains of gold. Clasped hands often signify marriage, friendship or, particularly when depicted on coinage, a link to the army. Should we consider this hoard as a visible link to imperial power in the region in some form? Taken in isolation, perhaps not, but material which is often associated with the Late Roman imperial bureaucracy such as crossbow brooches, strap-ends and Late Roman buckles have also been recorded from the site.

The Bowerchalke hoard is one of twenty-one recorded examples of coin hoards from Wiltshire that were deposited after AD 378. Significant peaks in coinage have been noted across sites in the county, particularly from the House of Valentinian (AD 364–78). After AD 364, there is a sharp increase in the supply for gold and silver coinage which peaks in the years AD 394–402. The quantity of coins and the significant peak in hoarding demonstrates Late Roman Wiltshire was a productive and wealthy agricultural landscape, able to produce considerable quantities of grain for export to the continent. The higher export of grain to the Continent appears to begin in the reign of Julian the Apostate (AD 355–63) (Moorhead 2009). It has been argued that this Valentinianic peak highlights an apparently relatively brief increase in rural activity and exported commodities.

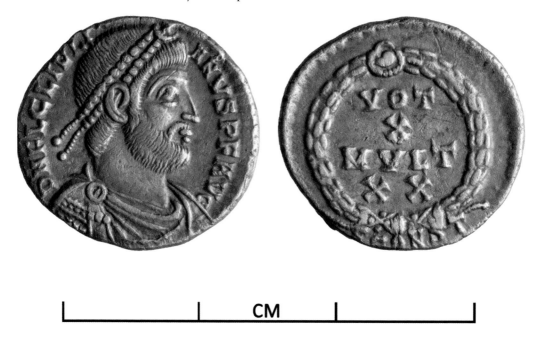

A silver *siliqua* of Julian II. (Salisbury Museum)

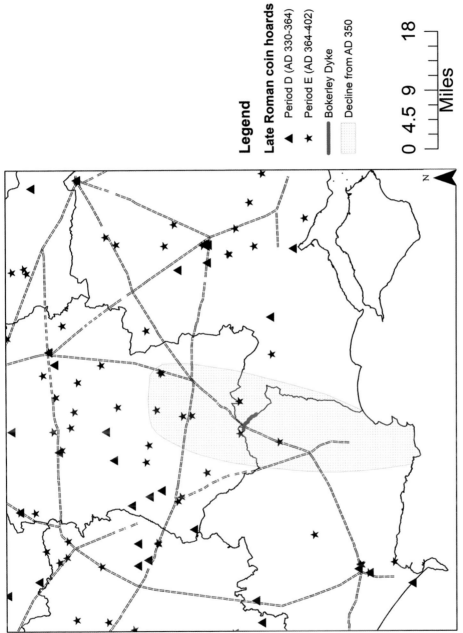

Area defined as having a decline in coin use after AD 350 mapped against Late Roman coin hoards and Bokerley Dyke. (Richard Henry)

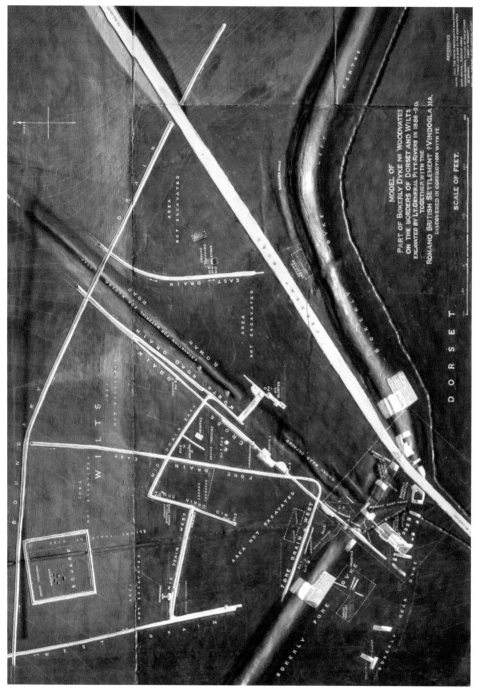

The Pitt-Rivers model of Bokerley Dyke. (Richard Henry)

The majority of hoards and coins recorded with the PAS which date from AD 330–364 are located in the centre and south of the county. During the Valentinianic period, although the main focus of material recorded by the PAS is still to the centre and the south of the county, hoards are more prominent to the north. This shift is further emphasised by the distribution of other artefact types including Late Roman belt fittings, such as the examples from Bowerchalke, along with the pewter and iron hoards from Manton, as well as the bronze vessel hoards from Pewsey and Wilcot.

Although the county is seen as prosperous in the mid to late fourth century as a whole, Bowerchalke is located in an area which Moorhead suggests declined from AD 350 onwards (see Henry and Ellis-Schön 2017). The numismatic evidence indicates a decline in coin use at sites such as settlements and there is a limited quantity of coin hoards from Salisbury to Purbeck region in this period.

Recent analysis suggests the major decline in coin use is actually to the south of Bokerley Dyke. The dyke is directly to the south of Bowerchalke, making the site an interesting case study. The dyke was initially excavated in 1888/90 by General Augustus Pitt-Rivers. He saw it as a defensive feature. It has since been suggested that Bokerley Dyke had a cultural significance. Bowen (1990) argues that the dyke only took its final form in the Late Roman period, when the dyke blocked the Roman road. In the post-Roman period, there was a similar cultural divide to the north and the south of the dyke. Does the evidence from the PAS dataset also highlight this at the end of the Roman period with a change in coin loss. It is possible that the numismatic evidence signifies a change in land use and a decline in coin use rather than an abandonment of settlements in the region (Henry and Ellis-Schön 2017).

The finds suggest a settlement which remained in use from at least the Late Iron Age until the Late Roman period. The coin hoards currently flank the date we can define for the site based on the artefactual and numismatic evidence. It highlights that coin use continued at the site for around 450 years and that the settlement had access to significant wealth even when this was no longer the case at sites directly to the south of Bokerley Dyke.

Turmoil?

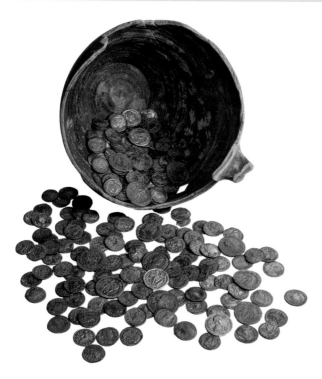

The Stanchester hoard.
(Richard Henry)

The Stanchester hoard was discovered in July 2000 by John and David Philpots near to the Stanchester Roman villa. It consists of 1,166 coins which had been concealed in an Alice Holt pottery flagon. The hoard includes three gold *solidi*, thirty-three silver *miliarense*, 1,129 silver *siliquae* and a single copper-alloy nummus. Two of the *solidi* were struck by the emperor Honorius in Ravenna, Italy between AD 402–06. The mint in Ravenna was opened in AD 402. By this time, the regular supply of fresh precious metal and base metal coinage to Britain is thought to have ceased. Therefore, coinage from Ravenna is rare in Britain. However, although regular imports ceased, that does not equate to a cessation in circulation. For example, in the western mints the production of bronze nummi ceased in Trier, Arles and Lyon around AD 395. Yet it has been argued that nummi continued to circulate as late as perhaps AD 425. Moorhead (2006) also notes examples of nummi in Wiltshire that were minted after AD 408 which suggests a limited supply into the fifth century for the county.

Nationally, there is the second highest peak in the number of coin hoards deposited at end of the fourth and into the early fifth century. The number of hoards from Wiltshire exceeds the national average, particularly hoards of silver coins. In the south west of Britain, the quantity of coin hoards, compared to hoards of precious metalwork, highlights that coinage was the principle means of depositing wealth in the region. This contrasts with the east of Britain where wealth was deposited in both forms (Hobbs 2005; Abdy 2013).

The widespread prosperity through the Valentinianic period, and probably for much of the remainder of the fourth century, contrasts strongly with the distribution of coins and hoards from the very end of the Roman period and into the post-Roman period. As discussed, there are a number of significant Late Roman hoards which date from AD 378 onwards, but only two hoards in Wiltshire (Boscombe Down and Stanchester) were deposited for certain after AD 402. However, there is strong numismatic evidence for the continuation of circulating coinage in the settlement at Boscombe Down, with hundreds of coins dating from AD 388–402 and a clipped *siliqua* discovered at the same time as the hoard. The limited evaluation of the Roman villa at Stanchester means the hoards are key evidential elements, suggesting continuing coin use at or in the environs of the villa.

Coin hoards can only be dated by their latest coin (described as a *terminus post quem*) and this does not always equate to when a hoard was deposited. It is possible that a number of earlier hoards might have been deposited after AD 402 as well when we consider the phenomenon of clipping. This is where the edges of the coin were cut down. Unlike many hoards in this period, the coins from Stanchester have not been clipped, which suggests that systematic clipping occurred after AD 402. The clipping of silver *siliquae* is generally accepted to have become widespread at the beginning of the fifth century and to have continued until at least *c.* AD 420, and possibly even to middle of the fifth century

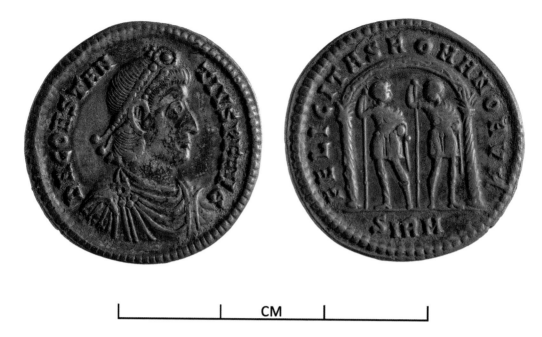

A silver *miliarense* of Constantius II. (Richard Henry)

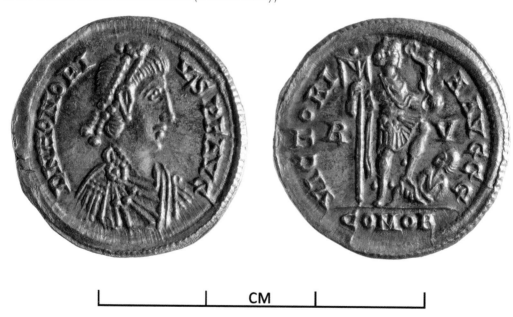

A gold *solidus* of Honorius struck at Ravenna. (Richard Henry)

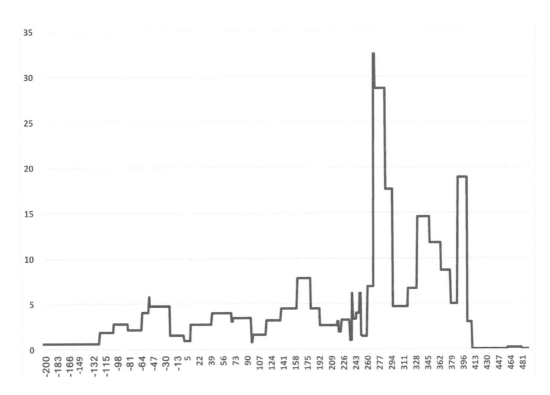

The number of coin hoards deposited per year during the Roman period. The final two decades of the Roman period have the second highest peak in coin hoards deposited after the mid to late third century. (Roger Bland)

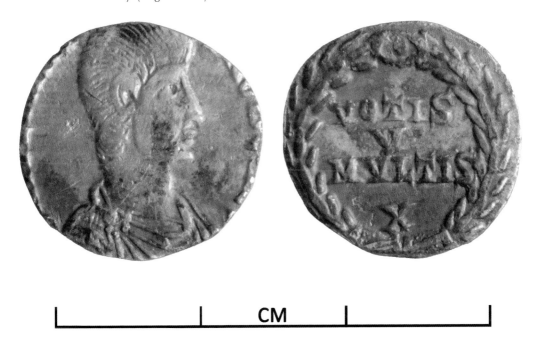

An example of a clipped *siliqua*. (WILT-DC35A4 – Salisbury Museum)

(Guest 2005; Abdy 2013). The reason why coins were clipped has been debated from different perspectives. Clipping of coins occurs in many periods, but unlike examples from the English Civil War, in the fifth century the clippings themselves do not appear to be regularly hoarded. In the English Civil War and other periods, clipping could be viewed as an attempt to defraud and make a quick profit. For the post-Roman period, it has been argued that *siliquae* were clipped to provide silver to create copies (Guest 2005). Considering how regular supply of silver dried up in the early fifth century, this is an interesting suggestion; perhaps highlighting that areas of Britain wanted to continue using coinage after the end of Roman Britain.

Clipping is therefore important as it provides an indicator of coin use in the decades immediately beyond Britain's final exit from the Roman Empire. Within Wiltshire, a number of hoards which have a *terminus post quem* of AD 378 or later have been heavily clipped. These hoards, which contain clipped coins, have been mapped with the hoards from Boscombe Down and Stanchester and single finds of clipped coinage recorded by the PAS. This indicates areas where currency potentially continued to circulate into the post Roman period.

For clipping to occur, *siliquae* must have continued to play an important role as currency or in exchange (Guest 2005; Hobbs 2005; Henry and Algar 2018). The presence of *solidi,* clipped *siliquae* and nummi minted after AD 408 in Wiltshire indicates links with Late Roman officialdom amongst sections of post-Roman society (Moorhead 2006, Henry et al. 2019). The evidence suggests that a tri-partite currency system remained in Britain until *c.* AD 425 (Walton 2012).

The quantity of hoards of varying types of coinage in the late fourth and early fifth century is significant. The numismatic evidence highlights the importance of the Stanchester hoard site and the Vale of Pewsey as a whole in the wider landscape. Indeed, it underlines that coinage remained in use in the environs of the hoard into the first (or perhaps the second) quarter of the fifth century. This corresponds with the rest of north Wiltshire, which appears to have remained prosperous into the second quarter of the fifth century (Henry *et al* 2019). When viewing the Late Roman hoards from the Vale of Pewsey as a whole, it is clear that whilst the social and economic circumstances were beginning to change, the area's links with Late Roman officialdom continued into the post-Roman period.

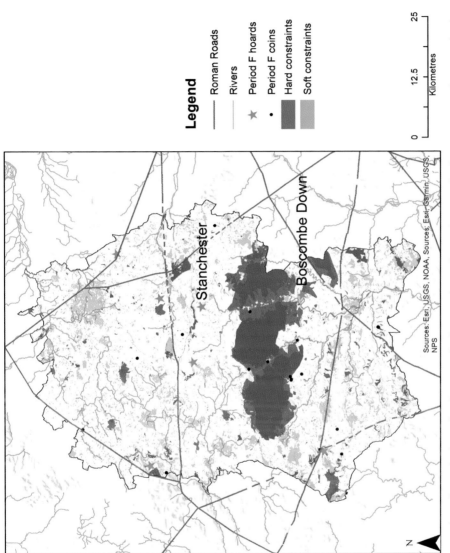

Legend

——	Roman Roads
——	Rivers
★	Period F hoards
•	Period F coins
▓	Hard constraints
▒	Soft constraints

Stanchester

Boscombe Down

Sources: Esri, USGS, NOAA, Sources: Esri, Garmin, USGS, NPS

N

0 12.5 25
Kilometres

Coin hoards and clipped *siliquae*, which may have been deposited after AD 402 along with the Stanchester hoard and the Boscombe Down hoard, and areas where metal detecting is banned (hard constraints) or unlikely (soft constraints) in Wiltshire. (Richard Henry)

The Box Coin Hoard
Period: Medieval.
Date of deposition: *c.* AD 1150.
Discovered: 1993–94.
Method of discovery: Metal detecting.
Contents: 104 silver pennies and cut fractions.
Current location: The British Museum and Wiltshire Museum, Devizes.

A selection of coins from the Box hoard. (Richard Henry)

Discovered in the early 1990s, the Box hoard of 104 pennies dating from the reign of Stephen, King of England, offers an interesting insight into the Anarchy – the civil war fought by the supporters of Stephen and another claimant to the throne, Empress Matilda, between AD 1135–53. During this period, royal control over the production of coinage collapsed. Deposited in *c.* AD 1150, unlike other contemporary coin hoards from the county such as Winterslow, the majority of

the hoard consists of issues struck for the Angevins (Matilda and her supporters) whose centre of power was at Bristol. It also contains the only examples of lion type issues struck for Robert of Gloucester and his son William FitzRobert known at the time the hoard was discovered.

Stephen was the third son of Stephen, Count of Blois-Chates and Adela, daughter of William the Conqueror. When King Henry I (*c.* AD 1068–1135) stated that he wished his daughter, Empress Matilda, to be his heir, Stephen was the first noble to swear an oath of support. Yet by the time Henry I died on 1 September 1135, the proposed succession had not been universally accepted. Sensing an opportunity, Stephen gained the support of the leading men of the realm and was crowned king on 22 December 1135.

In 1139, Matilda and her half-brother, Robert of Gloucester, landed in England and set up their Angevin power base around Bristol. She was also supported by her uncle, King David of Scotland. In February 1141, during the Battle of Lincoln, Stephen was defeated and captured and was subsequently taken to Bristol Castle. This could have resulted in the end of the war. However, in September 1141 Robert of Gloucester was captured after the Rout of Winchester, resulting in the exchange of these two high-profile prisoners. This ended Matilda's brief ascendancy in the civil war. By the middle of the decade there was stalemate, although there continued to be small skirmishes and sieges.

A silver penny of Stephen from the Latton hoard. (Richard Henry)

A silver penny of Edgar. (Salisbury Museum)

In 1153, Stephen's son, Eustace, died and Stephen announced the Treaty of Winchester where Matilda's son, Duke Henry, was declared his adopted son. When Stephen died on 25 October 1154, Henry inherited the crown, becoming King Henry II. It is in this setting that the coinage from the hoard can be considered.

200 years previously, from *c.* AD 973, during the reign of Edgar the Peaceful, coinage in England was produced to uniform designs at a series of mints located throughout the country. The reverse usually featured both the name of the moneyer who struck the coin and the mint where it had been struck. The designs generally changed every few years. England had one of the best quality coinages in Europe. Throughout the period, the penny was the main denomination coin struck, although some round halfpennies were subsequently produced during the reign of Henry I. To produce denominational fractions, pennies had to be cut in half (halfpennies) or into quarters (farthings). Pennies form roughly two thirds of the dataset of coins struck during the reign of Stephen, with the remaining third formed of cut fractions (Kelleher 2013). The regular reissues of coinage changed towards the end of his reign when longer-lived reverse types were introduced.

The coinage produced during the reign of Stephen falls into seven broad types. The two most common types in the archaeological record flank the start and end of his reign. The remaining five were produced not just by the King, but also Matilda and various bishops and barons. There are also examples where the dies have been obliterated. This highlights that the King had lost control over coinage production. The seventh and final type of the reign was an attempt to eliminate the issues

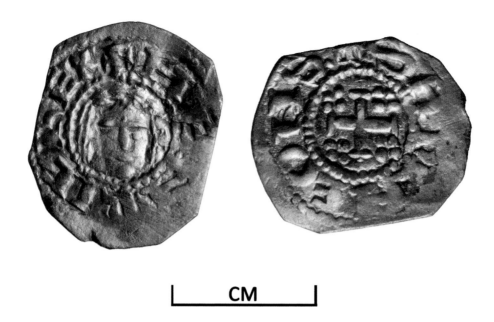

CM

A silver halfpenny of Henry I. (Salisbury Museum)

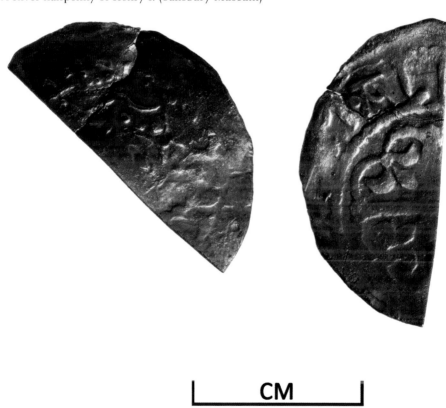

CM

A silver cut halfpenny of Matilda from the Box hoard. (Richard Henry)

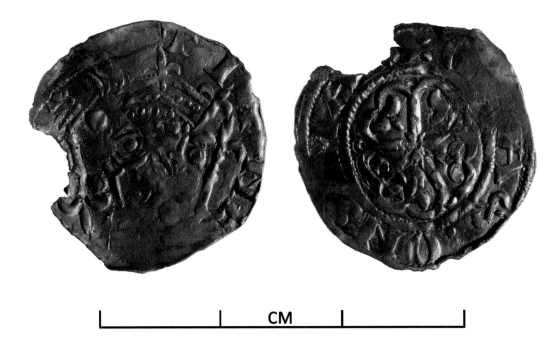

An obliterated obverse die of Stephen struck in Wilton. (Richard Henry)

struck by the wide range of characters during the preceding years, and to restore the circulating currency to that seen prior to the Anarchy. Mints that had not been active since at least 1125 were reopened and the production of the type continued to 1158, four years after Stephen's death.

The intervening five types discussed above therefore offer the greatest insight into the period and this is why the hoard from Box is so fascinating. We know of four hoards deposited in Wiltshire during the Anarchy: Box, Latton, Winterslow, and, Wroughton. Considering the hoard from Box in conjunction with the hoard from Winterslow provides a glimpse into how the coinage struck in the different spheres of influence circulated throughout the country. It could be argued that the types struck for both Stephen and Matilda were used to signify power. However, they could also have been struck because there was a need for additional coinage due to a significant lack of circulating currency. For the latter, there were groups struck in or around York, the Midlands and Southampton. In terms of distribution, the Southampton group broadly clusters around Winchester are found in the Winterslow hoard. Coins from York and the Midlands were much more widely distributed as demonstrated by their presence in the same hoard.

Unsurprisingly, given that Matilda's support was strongest in the South West region, this is where the majority of her coins are found. However, this region also saw coins being struck in the name of her half-brother and chief military supporter, Robert of Gloucester, as well as some minor barons. These coins are

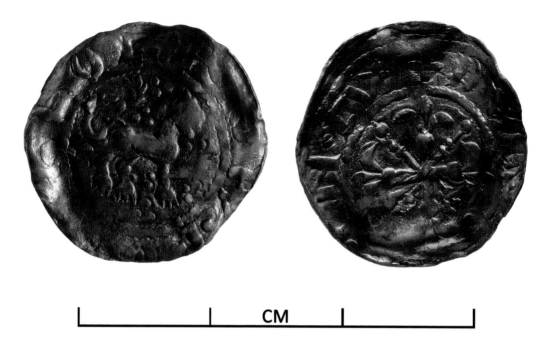

CM

A silver penny struck for Robert of Gloucester. (Richard Henry)

much rarer, with Box containing the only Lion type issues struck for both Robert of Gloucester and his son William FitzRobert. The find was made reasonably close to the regional centre of their powerbase. It has been suggested that it was Robert, rather than Matilda, who had effective rule of power in the south west. This might in part explain why the end of Matilda's brief ascendency coincided broadly with Roberts's death in 1147.

Although the Box hoard may initially appear insignificant in terms of the number of coins present, especially when viewed in comparison to a Roman coin hoard such as Frome which was comprised of 54,000 coins, it must be remembered that coinage from the Anarchy is much rarer. This is largely due to the quantity of coinage in circulation being lower. When considering coin hoards deposited in the years AD 410–1180, the Anarchy has the third highest peak after the period of Alfred the Great (871–99) and the Norman Conquest (1066).

The overall picture is somewhat obscured as we only see the surviving record. The final issue of Stephen attempted to redress the proliferation of coinage production during the Anarchy. This potentially means that a significant quantity of coins was deliberately removed from circulating currency, thus preventing further casual losses entering the archaeological record. Nevertheless, when mapping the stray finds from the period from the PAS and the Early Medieval Corpus of coin finds, the distribution emphasises that we should view the hoard as a significant deposit.

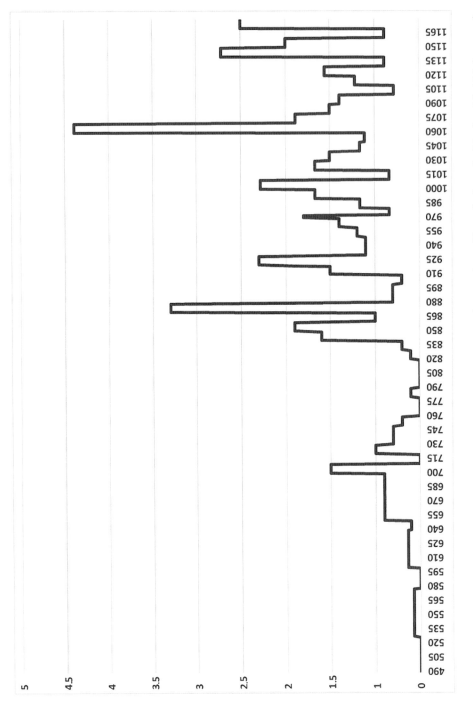

The number of coin hoards deposited per year between AD 490–1180. The number of hoards deposited is the third highest peak in this time frame after peaks in the period of Alfred the Great and the Norman Conquest. (Roger Bland)

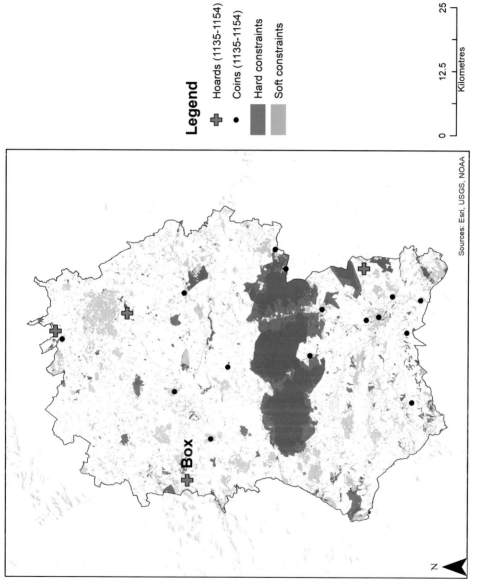

Map of the hoards and single coin finds derived from the Early Medieval Corpus and PAS in Wiltshire, which date the Anarchy and areas where metal detecting is banned (hard constraints) or unlikely (soft constraints) in Wiltshire. (Richard Henry)

The Wroughton Coin Hoard
Period: Post-medieval.
Date of deposition: After AD 1643.
Discovered: 1998.
Method of discovery: Building works.
Contents: 219 silver coins found within a vessel.
Current location: Swindon Museum and Art Gallery.

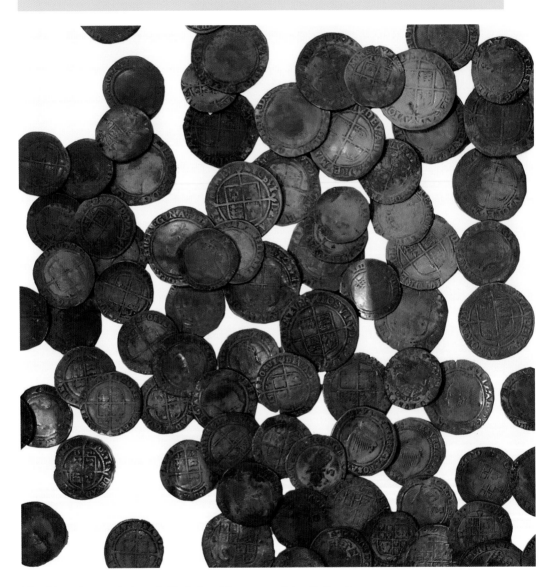

The Wroughton coin hoard. (Swindon Museum and Art Gallery)

The Wroughton hoard, which was hidden during the English Civil War (1642–1651) was rediscovered in 1998 during renovation works of a mid-seventeenth century cottage. It was found at a depth of around 1.2 m when the patio was being installed near to the back door of the property (Cook 1999).

The hoard consists of 219 coins minted between AD 1547–1643, worth £9 15s 8d. They span the reigns of five kings and queens of England and also include four Irish issues struck for King James I. There is some evidence for the clipping of the hoard coins. The group also highlights how residual issues might remain in the currency pool for over 100 years during this period and are often very worn.

As with Late Roman silver *siliquae*, clipping was prolific during the mid-seventeenth century, with many coins being heavily cut down. In some cases, whole hoards of clippings have been discovered. For example, the group from Alderwasley, Derbyshire. This is in part because the coins remained in circulation for such a prolonged period of time, and also because it was a quick way to make an easy profit for those with access to enough coins.

The latest issues in the Wroughton hoard were Royalist coins struck at Oxford in 1643. Wiltshire was in the area conquered by King Charles I supporters in the 1643 campaign and this in part explains why the hoard terminates with issues from Oxford. In 1642, Wiltshire had been held by the elite for the Parliamentary Party. The arrival of King Charles I in Oxford and the formation of the Royalist commander Lord Hopton's army shifted the balance of power in Wiltshire and the South West as a whole. In the winter of 1642, the towns of Marlborough and Malmesbury were captured by the Royalists and by late May 1643, Lord Hopton's army had captured most of south west England. Parliamentary resistance in Wiltshire was ended after the Battle of Roundway Down, near Devizes, on 13 July 1643. It then remained under Royalist control throughout 1644. During this time, Wroughton was located between the two main Royalist garrisons at Farringdon and Marlborough, a short distance from the main Royalist supply route between Bristol and Oxford. However, it was also not far from a Parliamentarian camp at Swindon.

So why was the hoard deposited in Wroughton? To the average soldier, the hoard would have been a significant sum. A day's pay during the Civil War was 8d, meaning the Wroughton hoard equates to roughly ten months' pay. It is unknown whether the hoard was deposited by a Royalist or a Parliamentarian and what the motivation was. However, we can say that whoever deposited it had access to the new issues struck by the Royalists at Oxford. The significant military activity during this period could mean that the hoard was deposited to prevent it being stolen or lost. It must also be considered though that there was significant pressure to contribute to the Royalists throughout 1644 and so it could be that someone was trying to protect their savings by hiding them.

A worn and clipped sixpence of Charles I. (Salisbury Museum)

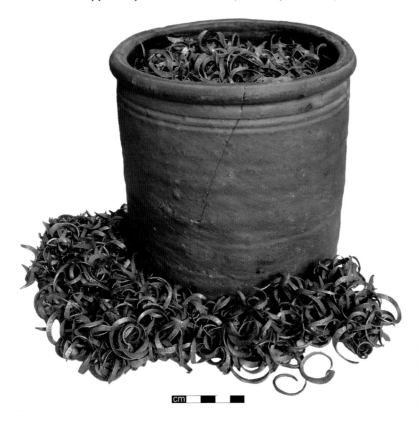

The hoard of
clippings from
Alderwasley,
Derbyshire.
(Derby
Museums Trust)

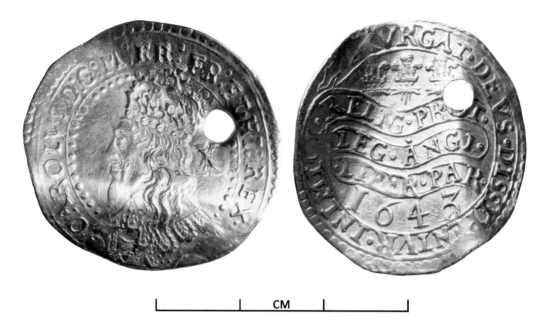

A gold half-unite of Charles I dating to AD 1643 from Thomas Bushell's mint in Oxford. The coin has been bent and pierced. It is likely that this example was used as a touch piece. (Salisbury Museum)

The Wroughton hoard brings to mind one of the most famous cases of historically recorded hoarding, known from the diaries of Samuel Pepys. During the Second Anglo-Dutch War in June 1667, the Dutch sailed up the Thames and the Medway. Pepys was deeply concerned and decided to send his wife and servant to his family estate in Brampton, Northamptonshire, to bury all the gold he could lay his hands on. In October, when the threat had passed, he attempted to retrieve the £2,300 worth of gold from where it had been hidden. Even though only a few months had passed he was unable to retrieve all of the money.

The peak in the number of coin hoards deposited during the English Civil War is substantial. Besly and Briggs (2013) have shown a correlation between the prolific number of coin hoards from Britain during the English Civil War and the key military campaigns. Coins from this period are dated by their initial mark which often span one or two years. When evaluating the hoards that can be closely dated based on the surviving evidence, they were all deposited in the years 1641–45, the earlier years of the conflict. Therefore, the evidence suggests the hoards were deliberately deposited due to the turmoil and external threats from the Civil War.

Ultimately, the external pressures faced during the Civil War campaigns in the region led to this hoard being deposited close to what is now the back door of a seventeenth-century cottage. It could be that whoever lived there, hid the hoard. It could also be that the location was chosen as an easily recognisable spot for someone to recover the coins in due course.

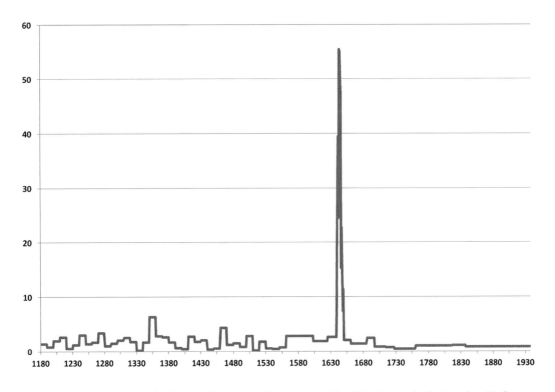

The number of coin hoards deposited per year from AD 1180–1930, the peak during the Civil War is substantial. (Roger Bland)

A shilling of Charles I with a star initial mark. The coin was minted in AD 1640/1 in London. (Salisbury Museum)

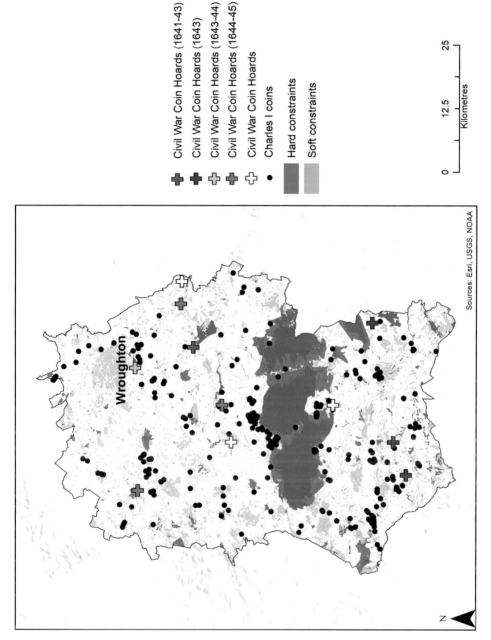
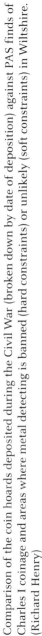

Civil War Coin Hoards (1641-43)

Civil War Coin Hoards (1643)

Civil War Coin Hoards (1643-44)

Civil War Coin Hoards (1644-45)

Civil War Coin Hoards

Charles I coins

Hard constraints

Soft constraints

Wroughton

N

0 12.5 25

Kilometres

Sources: Esri, USGS, NOAA

Comparison of the coin hoards deposited during the Civil War (broken down by date of deposition) against PAS finds of Charles I coinage and areas where metal detecting is banned (hard constraints) or unlikely (soft constraints) in Wiltshire. (Richard Henry)

93

Bibliography

Abdy, R. 2013, 'The Patching Hoard', in F. Hunter and K. Painter (eds.), *Late Roman Silver: The Traprain Treasure in Context* (Society of Antiquaries Scotland, Edinburgh), pp. 105–13.

Baldwin, A. and Joy, J. 2017, *A Celtic feast: The Iron Age cauldrons from Chiseldon, Wiltshire.* (British Museum Press, London).

Besly, E. and Briggs C, S. 2013, 'Coin Hoards of Charles I and the Commonwealth of England, 1625–60, from England and Wales', *British Numismatic Journal 83*, pp. 166–206.

Bland, R. 2018. *Coin Hoards and Hoarding in Roman Britain AD 43–c.498*, (Spink, London).

Bowen, H. 1990. *The Archaeology of Bokerley Dyke*, (HMSO, London).

Broughton, D. 2015, 'The Early Iron Age Socketed Axes in Britain', Thesis (PhD) (University of Central Lancashire).

Cook, B. 1999, 'New Hoards from Seventeenth-Century England', *British Numismatic Journal 69*, pp. 148–172.

Cunliffe, B. 1991. *Iron Age Communities in Britain*, 3rd edition fully revised, (Routledge, Abingdon).

Cunliffe, B. 1993. *A Regional History of England Wessex to A.D 1000*, (Harlow, Longman).

Cunliffe, B. 2000, *The Danebury Environs Programme: The Prehistory of a Wessex Landscape,* Volume 1; Overview. (English Heritage and Oxford University School of Archaeology, Oxford).

Dark, K. and Dark, P. 1997, *The landscape of Roman Britain*, (Sutton, Stroud).

Eagles, B. 2018, *From Roman Civitas to Anglo Saxon Shire: Topographical Studies on the Formation of Wessex*, (Oxbow books, Oxford).

Fowler, P. J. 2000, *Landscape Plotted and Pieced Landscape History and Local Archaeology in Fyfield and Overton, Wiltshire*, (Society of Antiquaries London, London).

Guest, P. 2005, *The Late Roman Gold and Silver Coins from the Hoxne Treasure,* (British Museum Press, London).

Henry, R. 2018, 'Using the Wiltshire and Swindon Historic Environment Record for Archaeological Research in South West Wiltshire', *Wiltshire Archaeological and Natural History Magazine,* pp. 111, 230–45.

Henry, R. Roberts, D. Grant, M. Pelling, R. and Marshall, P. 2019, *The Pewsey and Wilcot Vessel Hoards – The Context of Two Late Roman Vessel Hoards from Wiltshire,* (Britannia, 50), pp. 149–184.

Henry, R. and Algar, D. 2018, 'A Late Roman Silver Coin Hoard from Tisbury in Context: A Case Study for Dispersal through Agricultural Activity', *Wiltshire Archaeological and Natural History Magazine,* 111, pp. 311–17.

Henry, R. and Ellis-Schön, J. 2017, 'The Finding Pitt-Rivers Project: A Reassessment of the Numismatic Assemblage from Woodcuts in Context', *Wiltshire Archaeological and Natural History Magazine,* 110, pp. 179–90.

Hingley, R. 2006, *The Deposition of Iron Objects in Britain During the Later Prehistoric and Roman Periods: Contextual Analysis and the Significance of Iron,* (Britannia, 37), pp. 213–257.

Hobbs, R. 2005, 'Why are there always so many spoons? Hoards of precious metals in Late Roman Britain', in N. Crummy (ed.), *Image, Craft and the Classical World. Essays in Honour of Donald Bailey and Catherine Johns.* (Monogr., Instrumentum 29., Montagnac), pp. 197–208.

Hostetter, E. and Noble Howe, T. 1997, *The Romano-British Villa at Castle Copse, Great Bedwyn,* (Indiana University Press, Indiana).

Kelleher, R. 2013, 'Coins, Monetisation and re-Use in Medieval England and Wales: New Interpretations Made Possible by the Portable Antiquities Scheme', Thesis (PhD) (Durham University).

Lawson, A. J. 2007, *Chalkland an Archaeology of Stonehenge and its Region,* (Hobnob Press, Salisbury).

Lee, R. 2009, 'The Production, Use and Disposal of Romano-British Pewter Tableware, in *British Archaeological Report 478,* (Oxford).

Manning, W. H. 1972, 'Ironwork hoards in Iron Age and Roman Britain', (Britannia, 3), pp. 224–50.

Moorhead, T. S. N. 2001, 'Roman Coin Finds from Wiltshire', Thesis (MPhil) (University College London).

Moorhead, T. S. N. 2006, 'Roman Bronze Coinage in sub-Roman and Early Anglo-Saxon England', in B. Cook and G. Williams (eds.), *Coinage and History in the North Sea World c. 500–1250. Essays in Honour of Marion Archibald,* (Koninklijke Brill, Leiden) pp. 99–109.

Moorhead, T. S. N. 2009, 'Three Roman Coin Hoards from Wiltshire Terminating in Coins of Probus (AD 276-82)', *Wiltshire Archaeological and Natural History Magazine 102*, pp. 150–159.

Peal, C. A. 1967, 'Romano-British Pewter Plates and Dishes', *Proceedings of the Cambridge Antiquarian Society*, 60, pp. 19–38.

Rackham, O. 1986, *The History of the Countryside*, (Dent, London).

Roberts, D. 2014, 'Roman Attitudes towards the Natural World: A Comparison of Wessex and Provence, Thesis (PhD) (University of York).

Robinson, P. 1977, 'A Local Iron Age coinage in silver and perhaps gold in Wiltshire', *British Numismatic Journal*, 47, pp. 5–20.

Sealey, P. R. 1999, 'Finds from the Cauldron Pit', in N. R. Brown, 'The Archaeology of Ardleigh, Essex: Excavations 1955–1980', *East Anglian Archaeology*, 90, pp. 117–124.

Sherratt, A. G. 1996, 'Why Wessex? The Avon Route and River Transport in Later British Prehistory, *Oxford Journal of Archaeology*, 15*(2)*, p. 211–234.

Stead, I. 2000, *The Salisbury Hoard*, (Tempus, Stroud).

Van Arsdell, R. D. 1989, *Celtic Coinage of Britain*, (Spink, London).

Van der Veen, M. 2007, ' Food as an Instrument of Social Change; Feasting in Iron Age and Early Roman Southern Britain', in K. C. Twiss (ed.), *The Archaeology of Food and Identity; Centre for Archaeological Investigations Occasional Paper 34*, (Centre for Archaeological Investigations, Carbondale), pp. 112–129.

Wainwright, G. 1968, 'The Excavation of a Durotrigian Farmstead near Tollard Royal, *Proceedings of the Prehistoric Society*, 34, pp. 102–147.

Walton, P. J. 2012, *Rethinking Roman Britain: Coinage and Archaeology*, (Moneta, Wetteren).

Worrell, S. 2006, 'Finds Reported under the Portable Antiquities Scheme', (Britannia, 37), pp. 429–466.